The
Milk Mustache
Book

A Behind-the-Scenes Look
at America's Favorite Advertising Campaign

THE
MILK
Mustache Book

**A Behind-the-Scenes Look
at America's Favorite Advertising Campaign**

JAY SCHULBERG

with Bernie Hogya and Sal Taibi

BALLANTINE BOOKS • NEW YORK

A Ballantine Book
Published by The Ballantine Publishing Group

Text copyright © 1998 by Jay Schulberg
Photographs and advertisements copyright © 1998 by the National Fluid Milk Processor
Promotion Board

http://www.randomhouse.com

LIBRARY OF CONGRESS CATALOGING-IN-PUBLICATION DATA
Schulberg, Jay.
 The milk mustache book: a behind-the-scenes
 look at America's favorite advertising campaign
 /Jay Schulberg.
 p. cm.
 ISBN 0-345-42729-7 (alk. paper)
 1. Advertising—Milk.
 2. Milk trade—United States. I. Title.
 HF6161.M53S38 1998
 695.1'96371—dc21 98-21663
 CIP

Cover design by Bernie Hogya and Barbara Leff
Interior design by Michaelis/Carpelis Design Assoc. Inc.
Manufactured in the United States of America

First Edition: October 1998
10 9 8 7 6 5 4 3 2 1

IN THE BEGINNING, THE PAGE WAS BLANK.

Long before there was a milk mustache on a celebrity, there was a blank page, a team, and eventually an idea.

No one person creates a great campaign. Many people contribute. Over the years, scores of people at Bozell Worldwide and at our affiliated companies, especially Bozell Public Relations, have contributed to make milk mustache one of the most popular campaigns in the world.

Rather than try to name them all and inadvertently leave one person out, we would prefer to say a heartfelt thank-you to all. You know who you are.

There is a cliché in advertising that a client gets the advertising it deserves. A great campaign happens because great clients are involved. If a tip of the hat goes to anyone for the success of this campaign, it goes to our clients, who made it possible. Everyone from the milk processors in every part of the country to the board of directors to the advertising committee to the marketing group. Without them there would have been no milk mustache campaign, no chance to have made a bit of history.

A very special thanks goes to those who were there at the very beginning when the page was blank. Facing that blank page was the toughest challenge of all.

Finally, we would like to thank our editor, Amy Scheibe, who (with Stan Cohen) had the idea for this book and had the patience, forbearance, good nature, and talent to make us look better than we are.

All royalties have been donated by the authors to charity.

Milk. WHAT A SURPRISE!

"Finish your milk."

That was a phrase millions of Americans heard at the dinner table growing up, generation after generation, decade after decade. Beginning about thirty years ago it was heard less often. By the 1990s the consequences of drinking less milk were beginning to be felt and seen in the health of the American people. Osteoporosis, bone density loss, fractured bones and hips were taking an increasing toll. Those numbers would rise if kids growing up today, and even adults, didn't start finishing their milk.

Why had drinking milk fallen out of fashion? There are many reasons but the most damaging was the barrage of negative press in recent years that targeted the fat content and cholesterol levels of dairy products. Milk had also lost favor to sodas, bottled iced teas and "designer" waters. In the past decade, kids were more likely to down a liter of cola than drink a glass of milk. Sure cola is sweeter than milk, but it wasn't doing a thing for their nutrition.

In 1994, the nation's milk processors (the folks who package milk) felt it was important to get a health message to the American public. Congress agreed. So did the Secretary of Agriculture. What they wanted was an educational campaign that would reeducate the public about the importance of milk in their diets.

How does one reverse a thirty-year decline? How do you get people to think differently? Change their attitudes? How do you make milk cool? How do you compete for a share of mind when competitive drinks like sodas have been spending hundreds of millions every year, year after year?

You call in an advertising agency—Bozell Worldwide.

We accepted the challenge. Lots of research was done. We learned why many people stopped drinking milk or were drinking less.

But how could we get them to reconsider?

Fundamentally, it all came down to common sense. Don't tell me milk's good for me—my mother tried that one. Tell me something new and change my mind; make me look at milk in a new way. We knew that if we told you milk is good for you, most likely you would say, "Thank you very much, go away." Or if we told you milk builds strong bones you might respond with a tinge of sarcasm, "No kidding." *Then* mutter, "Go away." We had to tell people something new and meaningful, something they did not already know.

So we dug up some facts. Most people believed that when fat is taken out of milk all the vitamins and minerals go, too. Absolutely not true. Fat-free

and low-fat milk have all the calcium, vitamins and minerals as whole milk. Another fact: women need the calcium in milk for constant bone mass replenishment. If they don't get it, they risk bone density loss, fractured bones or osteoporosis later.

We called these facts *surprising nuggets of new information about milk.* They became the foundation of our campaign. The first year our themeline was, "Milk. What a Surprise!" The public gave it its own title: the milk mustache campaign.

A FACE THAT MAKES YOU SMILE.

The next question was: how do we create an educational campaign? Informational campaigns tend to be boring and lecturing—ours had to be simple, arresting, charming and fun.

We deliberately designed it as a poster campaign. We wanted a strong, surprising visual that would stop someone cold in a magazine. Think about it. Most magazines are crammed with editorial matter and cluttered with ads. Everyone is fighting for your attention. A poster with an unexpected face staring right back at you, especially if it were a face that made you smile or laugh, would probably stop you from turning the page.

Next, we limited the copy to only four lines. The opening and closing lines would reflect the personality of the person shown. Tucked between the opening and closing lines would be a surprising nugget of new information about milk. We believed that if the visual had stopping power and if the copy was charmingly and engagingly written, if it made you smile, we had a very good chance of getting our health message across. It reflects a fundamental truth about human nature: people are more likely to accept what you say if you present it in an engaging fashion rather than if you lecture them.

DEMOCRACY IS OVER. THIS IS WHAT WE'RE GOING TO DO!

Being a Creative Director is a fun job, although challenging and demanding. You are ultimately responsible for every television and radio commercial, every print ad, every creative piece that comes out of your agency. You are responsible for selling your clients' products and building their brands. You are responsible for creating work that is intrusive, persuasive and memorable. It must move or motivate the most detached person sitting in his or her home watching TV or thumbing through a

magazine who could not care less about the product you are advertising. You must stop a reader, prevent her or him from flipping the page. You can be funny or serious, rational or irreverent, whatever is appropriate for the brand, the product and the message.

Different Creative Directors act differently. Some say do it *my* way and consider a copywriter or an art director as nothing more than an extra pair of hands. I was never a fan of that philosophy. When I started out as a writer my attitude was, "Give me my head and let me run with it. If I screw up I screw up, but I can't be you. If you want it done your way, you do it." When I became a Creative Director I tried to remain true to this belief. I do not require writers and art directors to execute a campaign exactly as I would do it.

Still, even that philosophy has its limits. There comes a time when you have to say, *"Democracy is over. This is what we are going to do!"* And that's what happened with the milk mustache campaign.

We had about three weeks to come up with a campaign, a long time these days in the advertising business. I put a number of teams on it, including junior teams. When I became a Creative Director I swore I would give every kid a chance at doing a TV spot, a major print ad, even a campaign. One of the rewards of my job is discovering and mentoring kids who go on to become stars at major agencies around the world. I felt milk would be a perfect opportunity for young people to create a major campaign.

I was to leave shortly for Cannes, where the International Advertising Festival is held every year. Bozell Worldwide had won the Grand Prix in 1994 for the best commercial in the world from among about five thousand submitted. It was for Jeep, a spot called "Snow Covered," which shows a mysterious *something* burrowing through deep snow across a vast, frozen, lifeless tundra, turning left at a snow-encrusted stop sign, then continuing on unseen. At the end of the spot a title card comes on screen. It says simply: "Jeep. There's only one." The Grand Prix was a magnificent coup, for it was the first time an American spot won that coveted prize in nearly a decade. It also made history because it was the first American automotive product to win.

Just before I left for Cannes, I asked the teams of writers and art directors to show me where they were in the development of ideas. I would have very little time after my return before I was scheduled to show our recommended campaign to our client.

I was taken aback when the teams showed me their ideas. We had an upside-down cow. Why? I don't know except its creator thought it was cool. We had the word "milk" embossed on the side of the page. Do you know anyone who reads a page sideways? Better yet, do you know anyone who reads a page sideways looking for embossed letters? We were not off to an auspicious start. There was a milk mustache on some character but it did not jump out at me. I told the teams they should continue working and I would review their work in a week's time when I returned. The only thing I thought might have promise was the milk mustache but I thought that it had to be executed in an entirely different way. "Could we continue working on our other stuff, too?" one team member asked, meaning the upside-down cow and embossed lettering. "Sure," I replied, "but spend the bulk of your time on new ideas or the milk mustache."

The first Monday back in the office from Cannes I re-reviewed the work. The young teams re-presented the upside-down cow and the embossed word "milk." They said they had addressed the problems I had, or so they thought. Unfortunately for them, I didn't agree. When I asked for the new work, they stared at me blankly. They had done nothing new. Nor had they done any work on the milk mustache.

Democracy was over!

Coming to the rescue was Bernie Hogya, then an Associate Creative Director. Bernie is one of the best art directors at the agency. He is very strong in concept, meaning every ad must have a very strong and powerful idea. He also has a strong sense of design. I explained to Bernie what we had to do.

I also called in Jennifer Mantz, one of the young copywriters who originally had the idea for the milk mustache campaign. Jennifer has a wonderful sense of humor that is enhanced by her shyness, and I knew intuitively that she could bring her wit to the copy. Within forty-eight hours we had a blown-out, full-fledged campaign ready for the client, showing ordinary people sporting milk mustaches.

GREAT CLIENTS MAKE GREAT ADVERTISING.

A former advertising agency account executive with many years' experience, Charlie Decker had joined the National Fluid Milk Processors marketing staff several months before. There are all kinds of clients, but the best, those for whom copywriters and art directors will walk through fire, for whom they will toil all night and through the weekend, are like

Charlie. Open, friendly and encouraging, he doesn't try to do your job for you; he doesn't challenge you over every comma nor nitpick you to death over trivia. There are two ways for an idea to die in advertising: one big shark bite or nibbled to death. Either way it's dead. Charlie did neither. He gave us freedom to be our best.

Charlie loved the milk mustache campaign but had one request. Could we look at it using celebrities? If you have worked in an ad agency you'll know that many creative people will have a knee-jerk negative reaction to a client's creative suggestion. That response, of course, is inherently stupid and ultimately self-defeating. The best work happens when there is a living, breathing partnership not only between the agency and client, but also between the client and the creative team. If that happens, all great things are possible, and it shows in the work. Most often, when work is hackneyed, boring and pedestrian it happens because there was no partnership. Many clients have had great ideas and I have been fortunate to have benefited from them. Years ago when I worked at my former agency and we were developing the "Do You Know Me?" campaign for the American Express Card, the client suggested using successful people in the TV spots instead of "second bananas," the original concept. It certainly was a major reason why that very successful campaign ran for nearly a dozen years.

I have to admit I wasn't too keen at first on the use of celebrities; I always thought it was the last refuge of tired brains. That probably was because celebrities had been overused in advertising in the preceding two decades. Oftentimes, they were hawking products that you knew in your gut they never used. Paid shills. Celebrities are only effective if they are believable spokespeople for the product or the brand. However, Charlie asked, so we would try it. Again, Jennifer was the perfect choice to write the copy. She knew just about every movie and television star and could capture their personalities with humor in an instant.

Is using a milk mustache a new idea? No. Is using a celebrity a new idea? No. Is using a celebrity with a milk mustache a new idea? Yes! A very big idea, as it turns out.

E. Linwood "Tip" Tipton, Chairman, CEO and President of the Milk Industry Foundation, our most senior client—and Charlie's boss—together with his staff, Connie Tipton, Dawn Sweeney, Amy Heinemann and Charlie Decker, enthusiastically supported the campaign when shown the new material. Not long afterward the milk processors' Board of Directors

signed on, too. Eventually so did 72 percent of the milk processors in a nationwide referendum.

CAPTURING THE WORLD'S IMAGINATION.

The milk mustache campaign exploded like a gigantic fireworks display, catching on faster than any other campaign I created or was involved with. The milk mustache has become an icon of the nineties and part of pop culture. News about the campaign has appeared on hundreds of television stations and networks all over the globe. Articles have been written about it in magazines and newspapers from one end of the earth to the other.

Stuart Elliott, advertising columnist for *The New York Times*, picked it as one of the ten best campaigns of the year. Video Storyboard Tests, an independent research firm that measures the popularity of advertising campaigns, named it the most popular print campaign of the year with the American public. It was the first time in Video Storyboard's history that a campaign had become number one so fast.

USA Today named it as one of the top ten campaigns of the year, the only print campaign on the list. Dottie Enrico and Melanie Wells, *USA Today* reporters, wrote articles about it. Sally Goll Beatty, the *Wall Street Journal* advertising columnist, featured it prominently.

Tens of thousands of kids throughout the country, even the world, now collect the ads. Our Internet site, www.whymilk.com, is accessed by thousands of teens a week, and over forty thousand kids have joined Club Milk.

Every day we get requests from people who want to be in the campaign, including celebrities who ordinarily never appear in advertising. The requests come from all types of professionals, not just film stars, models or TV personalities.

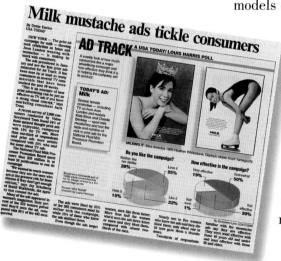

The milk mustache campaign has been spoofed, parodied and ripped off by countless others. Sitcoms draw on it as do movies; even other advertisers do. Jay Leno, in particular, loves to do his hilarious versions of celebrities with milk mustaches.

Most important of all, it helped reverse the thirty-year downward slide of milk consumption. Milk sales are now trending upward. The health of American women, American teenagers and college kids and American men is likely to improve as a result.

Milk had become cool.

SMART CALL: PUTTING ALL OUR EGGS IN ONE BASKET.

Early on in the development of the campaign, Chuck Peebler, CEO of Bozell Worldwide at the time, now President of True North Communications, the holding company of Bozell Worldwide, made two important strategic decisions. The first was to put the bulk of our advertising dollars into magazines only. Traditionally, almost without thinking, advertisers put all or nearly all their dollars into television. Chuck felt this was a losing proposition for us. Why? We had a big job to do, an educational campaign to get millions of people to change their attitudes toward milk. Also, our advertising budget of thirty-seven million dollars, although large, was not large enough to compete against soft drink campaigns.

We knew if we put our money into television it wouldn't go very far. By putting all our money into magazines we could in a sense own the medium, with ads in every magazine aimed at our target audience on a sustained basis. Also, by putting so many dollars into magazines we would be one of their biggest advertisers, and we could ask for and get added value. This came in the form of publishers providing special features on healthy living, cookbooks featuring recipes with milk (especially fat-free and low fat), calendars spotlighting celebrities with milk mustaches, to name just a few examples.

Chuck's second idea was to put a portion of our milk budget into public relations, which could be used to get important, positive news to the American public. Our surprising nuggets of new information about milk—the fact that women need the calcium in milk for constant bone replenishment, that teenagers and college kids also need it to offset osteoporosis, that milk has more nutrients than the leading sports drink—all could be communicated through a vigorous public relations program with educational videos, press information kits and a medical advisory panel, all instituted by Bozell Public Relations.

WE CALL CELEBRITIES. CELEBRITIES CALL US.

How would we get celebrities to participate? Most big-name celebrities are asked umpteen times a day to be in an advertising campaign. Most requests, if not all, are turned down.

What could we pay those who did join us? Very little, actually. Many celebrities earn hundreds of thousands of dollars if not a million or more annually. We could offer them only a pittance, comparatively speaking. We believed they would not be doing it for the money but for a greater good:

getting a health message to the American public. So we made our first decision. Every celebrity would be offered the same fee: $25,000. They could keep it or, if they preferred, donate it to charity, which some did.

I wrote a letter to the people we initially approached to be in the campaign. It explained why there was a very important health need for this campaign. The response was stunning. Over the years, we had more people who wanted to be in the campaign than we had space.

Later, Pete Sampras went so far as to send us a photograph of himself with a milk mustache. Academy Award nominee director Ron Howard wanted to do it because his daughter collects the ads. She thought it would be cool if he was in one.

One of Annie Leibovitz's most famous portraits was of Whoopi Goldberg in a bathtub of milk.

Who could be a better choice for our campaign?

Whoopi wanted to do it. We wanted to do it. We were all set. Whoopi had only one question: Would it be a problem because she is lactose intolerant?

Unfortunately, we had to decline. Everyone who appears in the campaign must be a milk drinker.

Who knows, Whoopi may yet appear! There are new studies that show that many people who are lactose intolerant can and should still drink milk.

AMERICA'S MOST CELEBRATED PORTRAIT PHOTOGRAPHER.

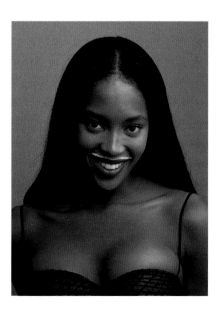

Bernie Hogya suggested using Annie Leibovitz, the celebrated portrait photographer who achieved fame and critical acclaim for her stunning work in *Rolling Stone* and *Vanity Fair* magazines. I first worked with Annie ten years before, when she became the photographer of the American Express "Membership Has Its Privileges" portraits campaign; the ones featuring Wilt Chamberlain and Willie Shoemaker, former Speaker of the House Tip O'Neill sitting barefoot on the beach and many, many others. At that time it was Parry Merkley, the creator of the American Express portraits print campaign, and Gordon Bowen who suggested Annie to me. Now it was Bernie. Annie's eye, staging and imagination create magic. Annie is unexpectedly down-to-earth, with no pretenses or airs. Intensely serious about her work, she is an absolute perfectionist and it shows in every photograph.

Annie works with us selecting celebrities, contacting them and creating the settings to put them in. The milk mustache campaign would not be as captivating as it is without the talent of Annie Leibovitz.

LAUNCHING THE PRINT CAMPAIGN OF THE NINETIES.

The first celebrities were carefully chosen to appeal to specific mini-targets within our overall target audience of women twenty-five to forty-four years of age. To make the biggest impression, we decided to launch with five celebrities in fifty-eight publications. Naomi Campbell, Christie Brinkley, Joan Rivers, Lauren Bacall and Isabella Rossellini launched the print campaign of the nineties. Within twenty-four hours Naomi Campbell's milk mustache picture was reported as *news* in newspapers, magazines and on television throughout the United States and the world. No one had anticipated a reaction like this nor had anyone ever seen an overwhelming instantaneous, worldwide response to a picture in a new advertising campaign. It took us delightfully by surprise.

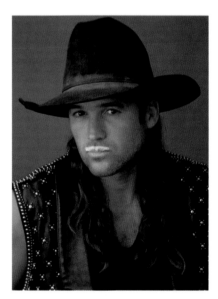

Women, men and children from Oshkosh to Oslo, from Milwaukee to Melbourne, from Paris, Texas, to Paris, France, were charmed by the milk mustache campaign. It touched a nerve. It made people smile. Why? Maybe the answer is as simple as seeing a world-famous person or one of the most beautiful women in the world with a milk mustache. We all relate to it. It reminds us of childhood.

Toward the end of the first year of advertising we decided to use men in the ads. Yes, we were still aiming our health message at women but if we could get to their hearts, minds and bones through hunks, so be it.

The first to run were Steve Young and Billy Ray Cyrus.

We asked people to vote for their most popular celebrity with a milk mustache. Guess who won?

Billy Ray!

WHERE'S YOUR MUSTACHE?

Some very significant things happened as we entered our second year. Kurt Graetzer joined the milk team as Executive Director, and helped take the campaign in surprising new directions that further fueled its worldwide popularity. Kurt strengthened the strategic focus of the campaign and directed its expansion, targeting new and different audiences. Under Kurt's leadership, the campaign soared to a higher plateau, constantly doing the unexpected, generating one newsworthy event after the other. If people thought that when they saw one milk mustache ad they had seen them all, Kurt turned their world upside down by constantly surprising them. A very engaging man, Kurt motivates people with his easy smile and by gently prodding them to rise to their very best.

As a result of our successful launch year, the budget doubled for years two and three, thanks in part to the masterful role played by Kurt and his staff. The doubling of the budget enabled us to reach other age groups in a meaningful and sustained manner. In addition to women aged twenty-five to forty-four, the campaign now included teenagers, college students and men. Each group could benefit from drinking more milk, but the reasons were different. Teenagers, especially girls, need milk during their growing years to help prevent osteoporosis later in life. Although most teenage kids believe they are bulletproof, the truth is the more milk they drink now, the less likely they'll suffer bone loss or hunched backs later. College students shy away from milk as soon as they are away from Mom; we needed to reach them with our message.

Instead of having a campaign aimed at one audience we now could tailor it with pinpoint accuracy to specific groups. We would use only the most appropriate celebrities with relevant health messages aimed at those groups in magazines of their choice. For example, a teenage girl reading *Seventeen* saw a different milk mustache celebrity and message than her older brother reading *Rolling Stone* or her older sister reading *Cosmopolitan*.

The expanded budget enabled us to go into other media, especially posters, something we wanted to do from the very beginning but couldn't afford. Simple, direct and fun, posters gave us the opportunity to have cute, clever or funny lines with irresistible faces that go with them.

Our biggest change as we entered our second year was creating what we called *moments of opportunity*. The lifeblood of an advertising campaign is coming up with ways to keep it fresh and unexpected. One of the best ways to do this is to take advantage of a moment in time, as in a significant sports event or an election or a news story that bursts onto the scene. These events are around us every day but believe it or not they are very hard to see. People are so caught up in the event itself that they can't see it as a newsmaking opportunity, for milk or for any other product. Our first one, featuring Clinton and Dole, was a huge success.

Finally, we changed our themeline as we began our second year. Since everyone called it the milk mustache campaign, why not have a line that said the obvious. *"Milk. Where's your mustache?"* became our new rallying cry.

The
Milk Mustache
Ads

Naomi CAMPBELL

The face that launched the milk mustache campaign.

Within twenty-four hours of its appearance, this picture of Naomi was published in newspapers all over the world as a *news* item.

After slipping into her little black dress, what Naomi really wanted was her pair of little black slippers. They were back in her apartment tucked away in her underwear drawer.

Imagine how many guys volunteered to get them!

NOVEMBER 7, 1994
NEW YORK CITY

You're probably going to hate me, but I've never dieted a day in my life. Being so busy, I usually just grab something real quick. Which is why I love milk. 1% lowfat. With all the same nutrients as whole milk, it's just what my body needs. Well, that and a closet full of ultrashort, supertight, little black dresses.

Joan RIVERS

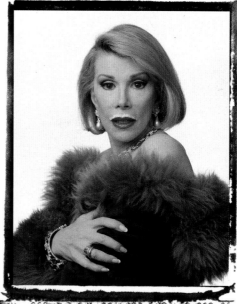

The first year we aimed our advertising to one specific audience, women aged twenty-five to forty-four. They were the ones most urgently in need of milk for good health. Women are also usually the gatekeepers, the ones who most likely do the shopping or decide what comes into the home. If they got the word that milk is important for their health, their family's health would also improve. We did not have enough money to reach everybody, at least in our first year, so we had to target our audience like a laser shot.

Should we have put a mustache on Spike's face, too?

NOVEMBER 7, 1994
NEW YORK CITY

Can we talk? Fattening? Oh grow up. It's skim milk—and I love it.
It has all the same nutrients as whole milk. They just take out the fat.
Between you and me Spike—no more problem thighs for us.

MILK
What a surprise!℠

IMAN

Iman is our *Mona Lisa*.

NOVEMBER 8, 1994
NEW YORK CITY

I have to admit—I was sort of born with this body. But that was a long time ago. And now I have to work hard to keep it up. So what do I recommend? Ice-cold skim milk. With nine essential nutrients and no fat, it's everything a woman could want. Well, that and a chance to meet my husband—I guess.

MILK
What a surprise!℠

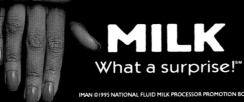

Vanna WHITE

When Vanna arrived at the studio, she brought her favorite guy with her.

All seventeen pounds of him.

Vanna was our first milk mustache mom. Only a handful of people have seen this outtake with Nicholas.

NOVEMBER 10, 1994
LOS ANGELES

Sure I worry about osteoporosis. Who wouldn't with over 20 million women suffering from it? Which is why I love skim milk. All the calcium helps keep my bones real strong, not to mention what it does for my perfect smile. And besides, if I started hunching over, I'd never be able to reach those high letters.

MILK
What a surprise!℠

Christie BRINKLEY I

One question we are asked time and again is about the milk mustache. Is it really milk? Is it other stuff? Do you *paint* it on?

Actually, the first five celebrities we featured in the campaign all had mustaches of 100 percent milk, but we found it dried too quickly under the lights. So we switched to a combination of milk and some other dairy products, including a little vanilla ice cream.

By the way, everybody's milk mustache looks different because of their head shape, lips, skin complexion and facial hair. It is almost as individual as their fingerprints.

You'll never guess who have the best mustaches. Women!

We'll let you guess why.

NOVEMBER 11, 1994
LOS ANGELES

What? I know — you've never seen a cover girl with a
mustache before. Well, get used to it. The milk, I mean. With nine essential
nutrients including calcium galore, it's one of the best things around.
Well, that and waterproof mascara, of course.

MILK
What a surprise!℠

Nastassja KINSKI

Nastassja Kinski is a beautiful actress who, in 1994, was known for two things: posing with a boa constrictor in a famous photograph, and playing a woman who was able to transform into a feline in the feature film *Cat People*.

So, if you've always wondered why Nastassja Kinski's ad copy mentioned playing a cat and posing with a snake…now you know.

NOVEMBER 11, 1994
LOS ANGELES

Maybe the fact that I've actually played a cat explains my
love for milk. Or maybe it's just that milk's got nine essential nutrients and
tastes great when it's ice cold. Who knows? But between you and me,
I'll pose with a mustache over a snake any day.

MILK
What a surprise!℠

Lauren **BACALL**

Ms. Bacall reigns as one of America's greatest personalities. She graces the stage and screen with class, elegance and style.

Recently, she was honored by President Clinton when he bestowed upon her a Lifetime Achievement Award in a ceremony at the Kennedy Center in Washington, D.C.

Her career began as a nineteen-year-old beauty when she starred with Humphrey Bogart in *To Have and Have Not*. If she was unknown the first moment she appeared on screen, it changed forever by the movie's end. She captured the hearts of millions.

NOVEMBER 12, 1994
NEW YORK CITY

I'm often called a legend, a title I'm less than fond of. In my eyes,
legends are dead. And me, well I feel more alive than ever. My secret?
Oh, maybe it's all the milk I have. 2%, ice-cold, straight up. With nine essential
nutrients including calcium, it's certainly better to have than have not.

MILK
What a surprise!℠

Isabella ROSSELLINI

Modest Isabella asked if we could run this picture with no copy.

She doesn't like to talk about herself.

We created a special two-page teaser titled, "Guess who's drinking milk?" It showed only beautiful lips with a mustache. Flip the page, and you found out whose beautiful face came with them.

**NOVEMBER 12, 1994
NEW YORK CITY**

Guess

who's

drinking

milk?

You can take me out of Europe but you can't take Europe
out of me. I have to have my cappuccino every morning. And what do I
put in it? Read my lips. Milk. 1% lowfat. I love it. It has all the same
nutrients as whole milk with less fat. Ciao!

MILK

What a surprise!℠

Joan LUNDEN

Joan had just gotten divorced. She has been so successful in her career, the judge awarded her husband alimony!

We put a little joke about it in our copy. Would Joan be game enough to accept it? We submitted it to her fully expecting a "no thank you."

Not only did Joan approve it, she loved it.

Laughter *is* the best medicine.

**FEBRUARY 1, 1995
NEW YORK CITY**

Most people think I must drink at least 10 cups of coffee
to be so perky in the morning. But the truth is, I like skim milk first thing.
It has all the same nutrients as whole milk without all the fat.
And besides, my husband got the coffee maker.

MILK
What a surprise!℠

Kate MOSS

Bones. Bones. All *dem* bones.
Even a world-famous model
known for her waif look needs milk.
Maybe more so.

This photograph worked because
it was edgy. It remains one of the
most talked-about in the campaign.

FEBRUARY 1, 1995
NEW YORK CITY

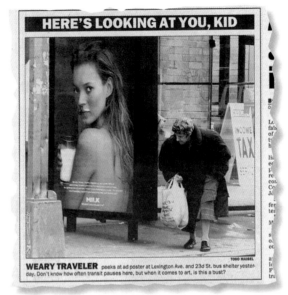

New York Daily News, February 1, 1995.

Bones. Bones. Bones. Maybe so, but unlike 75% of
women today, there's one way I'm taking good care of mine.
By getting lots of calcium. How? From drinking lots of milk. 1% ice cold.
And besides, haven't you heard that the waif look is out?

MILK
What a surprise!™

Kristi YAMAGUCHI

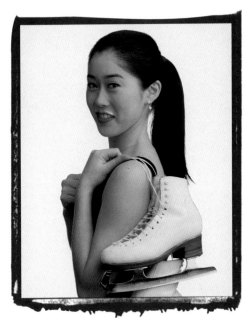

When we set out to photograph Kristi we faced a difficult challenge. It was the first time we needed to show someone from head to toe, er…head to skates, and still be close enough to see her face. To create the feeling of ice under her blades, we used reflective Plexiglas.

When we told Kristi there was a good chance the poster version might appear in the background of a feature film, Kristi asked if it was possible to get it into a Tom Cruise movie. Tom was her favorite actor.

As luck would have it, the film was *Jerry Maguire*.

JANUARY 18, 1995
LOS ANGELES

6.0, 6.0, 6.0, 6.0, 6.0! If I had to
rate milk as an after-sports drink, it would
definitely get the gold. Besides being
a better source of potassium than the
leading sports drink, it has more vitamins
and minerals per ounce. And how
do I like it? On ice, of course.

MILK
What a surprise!℠

Gabriela SABATINI

Beautiful on the court, beautiful off the court.

A female Adonis. A Greek statue-like pose.

<div align="right">

APRIL 11, 1995
MIAMI

</div>

You thought I'd be endorsing an after-sports drink.
And I am. Milk. 2%. Not only is it a better source
of potassium than the leading sports drink, but it also has
more vitamins and minerals per ounce. And besides
tasting great, it happens to go really well with all my outfits.

MILK
What a surprise!℠

Heather **WHITESTONE**

The Miss America Organization wanted reassurances we would photograph Heather Whitestone befitting Miss America. Hence the crown.

By the way, they have a sense of humor; take a look at the copy.

<div align="right">

APRIL 11, 1995
MIAMI

</div>

If I could solve one problem facing our children today, I would end world hunger, promote world peace, and then, if there was still time before dinner, I'd convince more people to drink more milk. Besides tasting great, three glasses of milk a day provide all the calcium you need, which in turn will make the world a better place.

MILK
What a surprise!℠

Steve YOUNG

Steve was photographed sweaty, dirty and heroic, as if he had just played in a game.

When Steve's postgame gear was being adjusted on him, Bernie Hogya, the campaign's art director, noticed that the makeup artist was applying greasepaint too low under Steve's eyes. She was placing it on the middle of his cheek rather than on top of the cheekbone. This was brought to her attention. Standing right in front of the Super Bowl MVP, she turned around and asked, "Does anyone here play football?"

How quickly they forget!

MAY 9, 1995
NEW YORK CITY

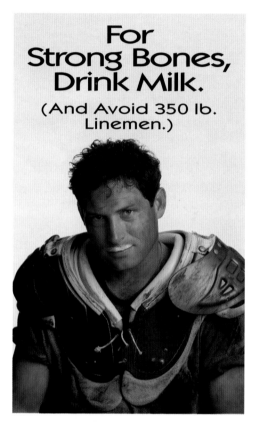

28

32-16-43-hike. And before you blink, 350 lbs. of solid mass is heading straight for your bones. What can you do? Well, besides pray someone's open—drink lots of skim milk. Not just for calcium but the eight other essential nutrients that keep your body strong in case you do get sacked. Man, I hate when that happens.

Billy Ray CYRUS

Billy Ray is a regular guy.

The first thing he did when he arrived was shout, "Turn off that music!"

The crew had been playing Billy Ray's latest CD to get everyone in the mood.

Billy Ray's smash hit "Achy Breaky Heart" made him a perfect choice for us because milk had just received the endorsement of the American Heart Association for being an important part of a healthy diet.

When we asked people who was their favorite milk mustache celebrity, Billy Ray won hands down.

Pretty good for a regular guy.

**APRIL 19, 1995
NEW YORK CITY**

If you won't listen to my advice on achy-breaky hearts, maybe you'll listen to what the American Heart Association has to say. They've also been singing the praises of 1% and skim milk as a way to reduce fat in your diet. And with all the same nutrients as whole milk, I believe they're headed for the top of the charts.

MILK

What a surprise!℠

Lisa KUDROW
AND
Jennifer ANISTON

Originally, we wanted to do a shoot with all six stars from TV's hit show *Friends*. It became impossible to line up all six on one day. The only two available were relative new-comers Lisa Kudrow and Jennifer Aniston.

We never guessed on that hot summer day that Lisa and Jennifer would become the most well known members of the cast by the end of the second season.

**JULY 19, 1995
LOS ANGELES**

We're such good friends, if I got
invited to a big Hollywood party,
I'd call you the minute I got home.
Or if you had stuff on your face,
I'd tell you, sooner or later.

Right, like now, sort of.
But this is to tell more women to
drink skim milk. It has all the
calcium without all the fat. Well,
isn't that what friends are for?

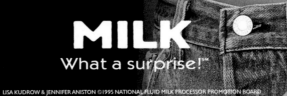

MILK
What a surprise!™

Christie BRINKLEY II

Christie Brinkley was the only milk mustache celebrity to be selected for an encore performance. This time, she posed with daughter Alexa Ray and her then new baby brother Jack Paris.

Alexa Ray spent a lot of time looking in the mirror while studying her mom's original milk mustache ad in the hopes of mimicking her perfect smile.

We think she did an excellent job, don't you?

JULY 19, 1995
LOS ANGELES

No caffeine. No alcohol. No sushi. When you're a pregnant or nursing mother there are lots of nos. But there is one big yes. Milk. And there's practically nothing your body needs more right now than all that calcium. Except sleep, but let's be realistic.

MILK
What a surprise!™

Tony BENNETT

Tony Bennett said the last time he saw a celebrity campaign as brilliant and simply executed as our milk mustache campaign was an old ad he remembered for Chock Full O'Nuts, which featured a close-up photograph of Jimmy Durante's nose sniffing the coffee.

When Tony saw himself in the mirror with his milk mustache for the first time, he said, "Hey, I look like Cesar Romero!"

We talked a little bit about Tony's talent as a painter, during which he said, "I really don't consider myself a singer who paints. I rather like to think of myself as a painter who sings."

Tony Bennett's milk mustache portrait is also a record holder of sorts. It was the shortest photo shoot ever. Five minutes, two rolls of film and a classic, endearing portrait of a musical legend.

SEPTEMBER 22, 1995
NEW YORK CITY

Talk about being hot. People just can't seem to get enough. Of milk, that is—skim and 1%. According to the American Heart Association, skim and 1% milk are a great way to reduce fat in your diet. Not to mention, they're especially popular with younger women. Notice any similarities?

MILK
What a surprise!℠

Pete SAMPRAS

When Pete arrived on the set, we were working out a pose. We asked him to hold the racket in one hand and stand with his legs apart in a semi-crouch with his head turned toward the camera. Pete laughed and said he wouldn't do it.

"Why?"

"Bad form," tennis's greatest pro replied.

After photographing for about thirty minutes, we were sure we had our shot.

Pete tossed a towel over his head, something he is in the habit of doing between sets, and started to walk off.

"Hold it!" we yelled.

Click. We had an even better shot.

We are deluged by celebrities who want to be in the campaign. Pete was one. He went so far as to send us a picture of himself with a milk mustache.

OCTOBER 13, 1995
NEW YORK CITY

Who better to endorse the all-American, nutrient-rich, wholesome beverage than me? I mean do you really think a radical-looking, earring-clad, stonewashed desert boy could convince women they need at least three glasses of milk a day to meet the calcium requirement? I don't think so.

MILK
What a surprise!℠

The PHANTOM

Actor Billy Zane took his character to heart. Everything he said was prefaced with "The Phantom wouldn't…" or "The Phantom would…"

Between each roll of film, Billy dropped down for a dozen push-ups. No costume padding here. Every muscle belongs to him.

He sits on the actual stone throne used in the film.

After the ad appeared, a Phantom collector sent us a page from an old Phantom comic book. In it, the Phantom enters a seedy bar, hops on a stool and orders a glass of milk!

Truth follows fiction.

Robert Evans, former head of production at Paramount Pictures and producer of such classics as *The Godfather* movies and *Chinatown*, also produced *The Phantom*.

When Evans saw one of the first milk mustache ads, he declared it "the campaign of the decade." He wanted the Phantom in one. He got his wish.

MARCH 15, 1996
LOS ANGELES

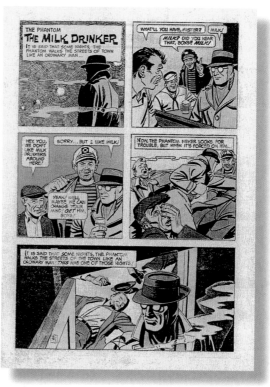

After a grueling day of defending the earth from piracy, greed and cruelty, I just can't wait to get home, kick back, and pour myself a drink. Of milk, that is. With nine essential nutrients that help make me strong, like protein, calcium and vitamin D, it's the beverage of choice for most superheroes.

Florence GRIFFITH JOYNER

What do you say about the fastest woman?

Saying the obvious was too obvious.

Our dilemma was solved when Flo Jo told us a story about herself. Her parents realized she had exceptional talent when she caught a jackrabbit!

You might say the copy wrote itself. At lightning speed.

MARCH 15, 1995
LOS ANGELES

How fast am I?
Well, I caught a jackrabbit
when I was 6, and in 1988,
I clocked in at 23.5 mph in the
100-meter. Sure, some of
that's natural, but I do train
hard and drink milk. 2%.
It's loaded with nutrients
like calcium and vitamin D,
so I drink lots of it.
Nice and slow.

MILK
Where's *your* mustache?℠

Danny DEVITO
AND
Rhea PERLMAN

Height notwithstanding, this Hollywood couple is larger than life. Danny and Rhea were appearing together in a new movie based on the popular children's classic *Matilda*. From the moment they stepped onto the set, the energy was incredible.

DeVito came out of his dressing room in really loud pajamas, smoking a Cuban, yelling in classic Louie DePalma style, "What's everybody still doing here? Go home already." After his third cigar, he became Arnold Schwarzenegger, his good friend. "I haff to smoke these before Ahhhnold gets them."

Although we had been inundated by requests from Hollywood studios and producers, we only went with two films, Danny and Rhea's, and Robert Evans's *The Phantom*.

MAY 3, 1996
LOS ANGELES

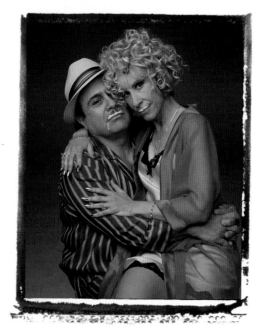

To us, looks are everything. Obviously. Which is why we eat well and drink so much skim milk. The calcium helps prevent osteoporosis— you know that thing that weakens your bones and can make you look like a human camel. And besides, it's got good taste, just like us.

MILK

Where's *your* mustache?℠

Spike LEE

We had worked with Spike many times before. He had starred in and directed a commercial for our client, *The New York Times*. Spike did the same for a former client, Taco Bell—a spot that also featured Shaquille O'Neal and Hakeem Olajuwon.

Thoughtful, gracious and very serious about his work, Spike is a true gentleman, an extraordinary talent who rightfully has emerged as one of America's great young directors.

Spike appeared in one of our first billboards and was soon followed by Kate Moss, Patrick Ewing and David Copperfield.

MAY 6, 1996
NEW YORK CITY

Here's the direction.
You thought milk was just
a kid thing. But the plot
thickens and you discover
your bones are still
growing until you're 35.
You're on a mad quest for
calcium. AND... ACTION.
You open the fridge,
you grab the lowfat milk,
you drink it. CUT.
Not from the carton.
TAKE 2. Let's use a glass.

MILK
Where's *your* mustache?℠

Frank GIFFORD,
Bob COSTAS AND
Al MICHAELS

"**W**here's Dan Dierdorf?" People
always ask about the missing third
of the *ABC Monday Night Football*
threesome of Dan, Al Michaels and
Frank Gifford. We'll never tell.

Besides the shot of the three men
wearing their best announcing shirts
and ties, we also tried a concept
where all three were wearing casual
clothes. Everything was going fine
until Al Michaels pulled the brim
down on Bob Costas's hat, pushing it
down over his eyes. He looked up
and exclaimed, "That photo will
never run."

MAY 7, 1996
NEW YORK CITY

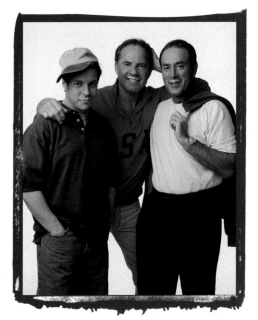

Here's the call. Man rushes for 175 yards. He sweats. He needs nutrients.

He drinks a leading sports drink. He replenishes fluids, not nutrients.

Later, he drinks milk. He gets calcium. Potassium. Other nutrients. The fans go wild—they start the wave.

MILK
Where's *your* mustache?℠

AL MICHAELS, FRANK GIFFORD & BOB COSTAS ©1996 NATIONAL FLUID MILK PROCESSOR PROMOTION BOARD

Ivana **TRUMP**

Ivana Trump is one of the richest, most glamorous women in the world.

What copywriter wouldn't give his or her word processor to capture her accent? Isn't that so, dahling?

MAY 9, 1996
NEW YORK CITY

50

Rich. Rich. Rich. Ahhh.
Skim milk is so rich in calcium,
I drink as much as I can.
It has all the nutrients
without all the fat.
And dahling, the one thing
nobody can afford is
too much fat.

MILK

Where's *your* mustache?℠

Patrick EWING

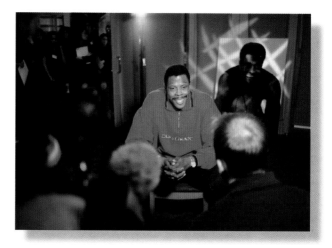

Patrick was photographed in a Manhattan studio complex large enough to house multiple shoots at the same time.

Just after arriving, Patrick asked directions to the john. "Turn left, make the first right."

Fifteen minutes went by. Twenty minutes. Where was Patrick? Should we send out a search party? How do you lose a seven-foot legend?

Patrick returned grinning ear to ear. "You guys set me up."

When he left the studio Patrick made his first right, not left. He landed in another studio, packed with kids. Pandemonium. Imagine your kid looking up and seeing Patrick Ewing. He spent the twenty minutes or so shaking hands and signing autographs.

It didn't stop there. Once we started shooting Patrick with his milk mustache every kid that walked by would wave to him. He kindly waved back.

Finally we had to lock the door.

Patrick had one regret. Tyra Banks was to be photographed next and he wanted to meet her. Unfortunately, her plane was late and he never got his chance.

MAY 9, 1996
NEW YORK CITY

52

Have you seen me sweat? I must lose 10 lbs a game. And from what I hear,
it's not just about losing water. It's about nutrients. That's why I drink milk. 2%.
It's got nine essential nutrients my body needs, like calcium and potassium. I thought
about telling the boys in Chicago, but it's about time they lost something.

MILK

Where's *your* mustache?℠

Tyra BANKS I

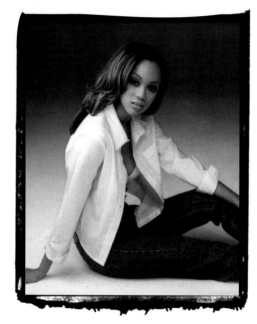

Tyra flew the Concorde in from London. At the studio, she was hustled in for the standard two to three hours of hair and makeup that transform drop-dead beautiful models before hair and makeup into drop-dead beautiful models after hair and makeup.

All that stuff about how super-models don't look beautiful until they've been magically transformed by professionals with mascara and lip gloss is bunk.

Tyra wasn't impressed by the studio-catered food spread and asked for a burger and fries. Then she slipped into a string bikini.

The first milk mustache photo of Tyra was targeted at teenage girls. There was no way that a photo of her in a teeny-weeny itsty-bitsy yellow-gold string bikini would be accept-able in publications like *Seventeen*. It was too sexy. So it sat in a drawer until it was pulled out for a one-time only insertion in *Sports Illustrated*'s acclaimed swimsuit issue.

Flip to page 130 to take your breath away.

MAY 9, 1996
NEW YORK CITY

Girls, here's today's beauty tip. Think about you and your 10 best friends. Chances are 9 of you aren't getting enough calcium. So what? So milk. 3 glasses of milk a day give you the calcium your growing bones need. Tomorrow— what to do when you're taller than your date.

MILK

Where's *your* mustache?℠

Yasmine BLEETH

Long before we ran an ad with Tyra Banks in a swimsuit, we had Yasmine Bleeth.

We call this the "eat your heart out" shot. It was the first milk mustache ad to run in the *Sports Illustrated* swimsuit issue.

At first, Yasmine wasn't sure she wanted to pose in a swimsuit. She wanted to move beyond her *Baywatch* image. We *begged*. She relented but with one restriction: it couldn't be a red swimsuit. We designed this white-on-white number.

It is one of the most requested posters in the campaign.

Swimsuits go great with milk, don't you think?

**JUNE 25, 1996
LOS ANGELES**

When I'm not giving mouth-to-mouth or consoling a fellow lifeguard with sun-damaged hair, I worry about real-life things like getting osteoporosis when I'm older. You know, men and women are both at risk when they don't get enough calcium. That's why I drink lots of milk now. 1%. And depending on how much I drink, I wait a half hour before saving a life.

MILK
Where's *your* mustache?℠

Daisy FUObjectNTES

To reach the college crowd, we went with former MTV VJ Daisy Fuentes. Now as everyone knows, Daisy is a very sexy woman. She's very self-confident and loves to have fun. Of all the tasks we've faced producing the milk mustache campaign, choosing one single Daisy Fuentes photo was our hardest job. Take one look at these shots and you'll see why.

We opted for the one that had an edge to it. She seems to be taunting you: "Yeah, so what? I'm drinking milk. What's that to you?"

Daisy appeared on the back cover of *Rolling Stone* featuring Sheryl Crow on the cover. Soon after, this letter appeared in *Rolling Stone*: "With Sheryl on the front and Daisy on the back, everything in between was just gravy. Thank you."

Daisy's ad was one of our first translated specifically for the Hispanic market.

**JUNE 25, 1996
LOS ANGELES**

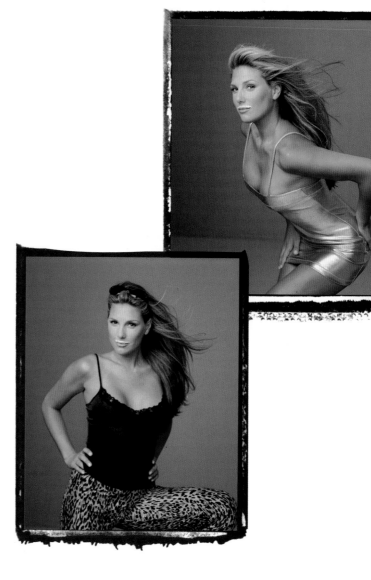

Girls, let's talk about the "F word." FAT. It's no good, right? So I've got a solution. Drink 3 glasses of fat free milk a day and you'll be getting all the calcium you need, without the fat. So check it out. Ciaocito, baby!

MILK
Where's *your* mustache?℠

Matthew FOX

When Matthew Fox signed on, we tapped into something that's pretty obvious: there's nothing better to capture the attention of teenage girls than cute guys. Trust us, it works.

If we were asked to pick the top ten moments in milk mustache lore, this was surely one of them. Overnight, Matthew Fox became America's favorite pinup. Teenagers across the country cut the ad out of their favorite magazines and put it on their walls above their beds.

It might just be the ad that started the milk mustache ad-collecting mania.

For the record, Matthew was a little hesitant when the stylist put gel in his hair. His nervousness turned to smiles when he saw the first Polaroid. "I *love* the hair!"

JUNE 24, 1996
LOS ANGELES

I'm not a commitment phobic, I just play one on TV.
In real life, there are lots of things I'm committed to. Like, take
my health. They say 3 glasses of milk a day give you
all the calcium you need. So what do I do? Run away?
Make excuses about being too young, not ready? No, I drink it
like a real man — straight from the carton.

MILK
Where's *your* mustache?℠

Neve CAMPBELL

We photographed Neve Campbell just one day after *Party of Five* costar Matthew Fox.

She roared with laughter when she saw his photo.

Was it the milk on his lip? Or the spiked hair?

Neve wasn't saying. Only laughing.

JUNE 25, 1996
LOS ANGELES

Guilty or not? Do you cross out the waist size on your jeans?
Listen, it's totally pathetic, but how can we not? Everyone talks about
losing weight. My advice? 1% milk. 3 glasses a day. It has all the
calcium you need and less fat. Now there's a fashion statement.

MILK
Where's *your* mustache?℠

Cal RIPKEN JR.

The only thought going through our minds at the shoot was, "Please God, don't let Cal trip on a wire, sprain his ankle and miss a game."

If there ever was a model for a sports hero, Cal Ripken would be at the top of the batting order. He is the nicest guy with the sweetest personality.

Imagine our reaction when we heard the news that Cal broke his nose at his next photo shoot.

Even then he didn't miss a game.

**JUNE 28, 1996
NEW YORK CITY**

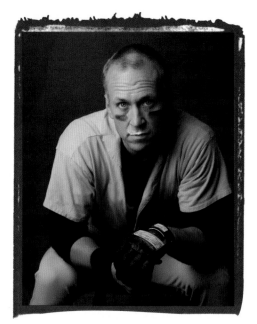

With all the milk I drink,
my name might as well be
Calcium Ripken, Jr.
Really, I'm a huge milk fan.
Besides being loaded
with calcium, there's nothing
like it when it's ice cold.
Which is why I drink
the recommended 3 glasses
a day. And as you'd
probably guess, I'm not one
to miss a day.

Where's *your* mustache?℠

Oscar **DE LA HOYA**

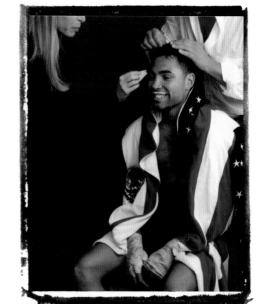

Oscar brought along a few items for the shoot. His boxing gloves, trunks and an absolutely amazing robe picturing the American flag.

Jay Jasper, former creative director at Ogilvy & Mather, responsible for some of advertising's most celebrated and award-winning campaigns including the trendsetting Paco Rabanne print campaign in the eighties, told us this was our best photograph yet.

High praise, indeed.

JULY 23, 1996
LOS ANGELES

What? Were you expecting
Hercules or something? Listen, I've
got three words for strong muscles.
Fat free milk. We're talking high-quality
protein for your muscles without the fat.
And man, there ain't nothing uglier
than an overweight lightweight.

MILK

Where's *your* mustache?℠

Dennis **RODMAN**

It didn't take long for us to dismiss our first visual ideas.

Dennis in a wedding gown.
Dennis in a red-sequined dress.

We decided he looked better without a dress.

It was the first milk ad to run in three colors.

Doesn't he look better in red?

What's your favorite?

JULY 23, 1996
LOS ANGELES

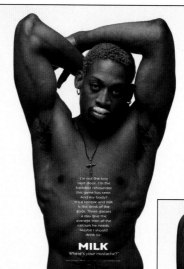

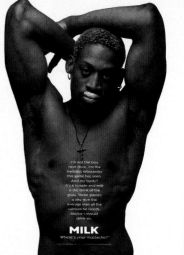

I'm not the boy
next door. I'm the
baddest rebounder
this game has seen.
And my body?
It's a temple and milk
is the drink of the
gods. Three glasses
a day give the
average man all the
calcium he needs.
Maybe I should
drink six.

MILK

Where's *your* mustache?℠

Amy VAN DYKEN

Annie Leibovitz had a great idea for photographing Olympic swimmer and multi-gold medal winner Amy Van Dyken.

Underwater.

How did we make sure her milk mustache stayed on?

Some secrets we won't tell.

OCTOBER 17, 1996
LOS ANGELES

In addition to the crawl and the butterfly, I can perform a world-class chug-a-lug. With milk. It has protein for my muscles, plus essential vitamins and minerals like calcium and potassium. All of which help me get the one mineral every Olympian craves. Gold.

MILK
Where's *your* mustache?℠

Zoe KOPLOWITZ

The only non-celebrity to appear in the campaign, Zoe Koplowitz is a genuine American hero. We can say that about her, of course. Zoe never would.

Stricken with multiple sclerosis in her mid-thirties, Zoe refused to be defeated. Every year for the past ten years Zoe has "run" the New York Marathon. Every year she finishes regardless of how long it takes.

Even if it means crossing the finish line with the rising sun.

OCTOBER 21, 1996
NEW YORK CITY

I will never
finish the marathon
before sundown
or even sunrise
the next day.
But I will finish.
Because I am an athlete.
An athlete with
multiple sclerosis.
So I train
and I drink milk
because an athlete
knows you
need protein
for your muscles
and calcium
for your bones.
And that helps
keep my body going.
And what keeps
my mind going?
The fact that I am
an athlete.

MILK

Where's *your* mustache?℠

CLINTON/DOLE

"Air Force One is on the phone." The call had come to Carter Eskew of Bozell Eskew, a firm that Bozell Worldwide owns in Washington, DC. It specializes in advocacy and issue advertising.

That Monday, the day before Election Day, 1996, this ad featuring Clinton and Dole with milk mustaches appeared in *USA Today* and *Newsweek*. Only one line of copy appeared: "Vote. Strengthen America's Backbone."

I had been tied up all morning in a meeting that ran till noon. My secretary was out ill. Normally she would call me or even come get me if something important had come up. When I returned to my office I discovered that all hell had broken loose. There was a stack of messages from the news media asking for interviews. TV crews were coming in to set up shoots with me to air that night. On my desk was a thick stack of mail in a closed folder. I opened the folder to see a fax from Carter about the Air Force One call. In that one split second I suddenly realized that Bill Clinton really was the President of the United States. They are not just "Bill" and "Bob," just

two guys as they wanted you to think of them, running for President. In that instant, I saw myself in Leavenworth! We had not cleared the ad with the President or the Senator. After all, it was in support of getting out the vote. Who can argue with that?

Carter's fax went on to say although some people on the presidential plane were taken by surprise, the President was perfectly fine with it. In fact, he issued a statement saying he supported its purpose, voting. Senator Dole issued a similar statement.

Thank you, Mr. President. Thank you, Senator Dole.

NOVEMBER 4, 1996

WINNERS & LOSERS

IN THE PRE–SUPER BOWL BALLYHOO, HYPE, HOOPLA & HUBBUB ...

BOB DOLE
A milk mustache, a fling with Air France and now a Super Bowl commercial for Visa

BRETT FAVRE
Fit, fleet, favored. And he hails from next door to the Dome: Mississippi

JAMBALAYA
Hold the clam chowder! They're hungry in Beantown, and they're craving creole cuisine

ANNETTE FUNICELLO
Her biopic joins *Lois & Clark* in Mission Impossible: scoring rating points against Fox

DALLAS COWBOYS
Abandoned as America's team. Green Bay merchandise sales are gaining ground fast

NEW ORLEANS INSPECTORS
Big question in the Big Easy: Any way to enforce the city's ban on renting to transients?

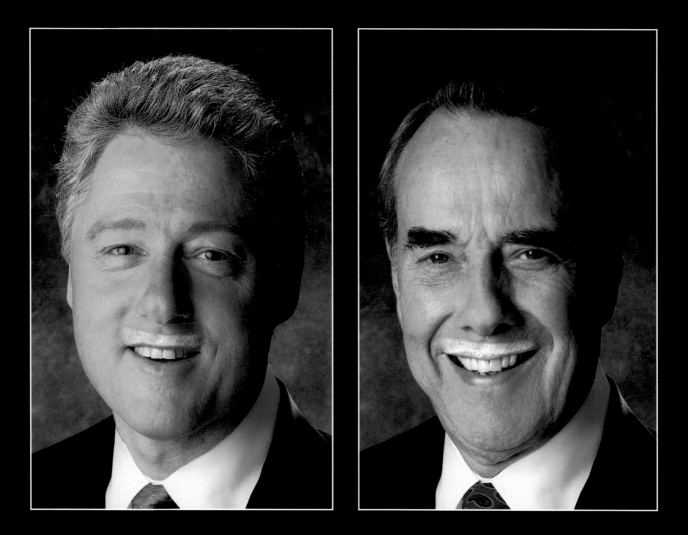

Vote. Strengthen America's Backbone.

MILK

Where's *your* mustache?℠

VAN HALEN

During the Eddie and Alex Van Halen milk mustache shoot, the brothers behaved like true brothers.

We began shooting Eddie and Alex side by side. They smiled. They hugged. Eddie played his guitar. Eddie was asked to hold a milk glass.

Then they exploded.

"Hey, man! We don't have to pose like Daisy Fuentes," Eddie shouted. "This is rock and roll! We can do anything we want!"

Alex egged his brother on. "Pour it on my head, man!"

Instinctively, we snapped the shot.

DECEMBER 16, 1996
LOS ANGELES

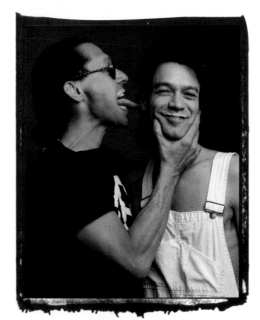

Of all the lead singers we've had, most never got
enough calcium. Typical. But not for Alex and me. Because
every time we change singers, we have an extra glass of milk.
That way we're sure to get more than the recommended
three glasses a day. As you can see, sometimes all at once.

Martha STEWART

We couldn't have written it any better.

We are in the middle of a corn-field somewhere deep in New Jersey. Our bus is stuck in the mud. The cows aren't cooperating. The Teenage Dairy Princess shows up having heard that Martha Stewart was coming. Martha arrives, unfazed, in overalls, carrying the most perfect bundt cake.

Cotton was the cow's name and drooling was her game. She drooled so much, she ruined Martha's designer coat.

Which led to the last line of copy.

Martha told Cotton: "You'll never work in this town again!"

DECEMBER 18, 1996
NESHANIC, NEW JERSEY

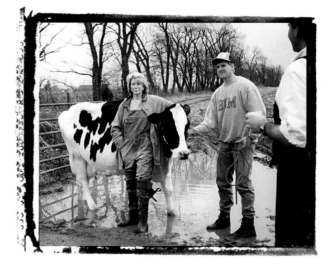

Three words. Just add milk. It's a good thing. Whenever
appropriate, substitute milk for water in your recipes. It enhances
the dish, and the calcium and other nutrients enhance you. Next time,
how to remove spots from your coat. No offense.

MILK
Where's *your* mustache?℠

Jeff GORDON

After photographing Martha Stewart and a cow, we couldn't wait to get Jeff Gordon's car into the studio. The car did present different lighting challenges than the cow, but at least it didn't drool. The only drooling on the set was from the guys on the crew who couldn't believe they were standing so close to one of the fastest cars in the world, at least when Jeff is behind the wheel.

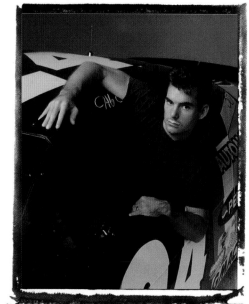

One detail on Jeff's car was particularly intriguing; for all of its technological prowess, the car's dashboard controls were deceptively simple. In fact, there was a single ON/OFF switch. Jeff's manager told us that the switch was added because Jeff kept forgetting his car keys.

"I am sure that when I was a little baby that I was drinking milk before I was driving race cars," Jeff said. "At the last banquet that I won a Championship I did a milk toast to a competitor. So, I'm sure that we'll keep that tradition going and toast to milk instead of champagne...just for fun."

DECEMBER 19, 1996
NEW YORK CITY

80

At 24, I became the second youngest champion in NASCAR history. Here's another little-known fact. Of the 42 drivers who chase me at more than 200 mph, most don't get enough calcium. My advice? Drink three glasses of milk a day. Preferably while standing still.

MILK

Where's *your* mustache?℠

Lisa AND *Bart*
SIMPSON

The Simpsons' shoot did not go smoothly.

Bart and Lisa were posed to look nice and charming. Bart was on particularly good behavior, arriving for the shoot with his hair neatly combed and wearing his Sunday best. But every time we tried to take the picture, Bart moved.

This was his least offensive pose.

JANUARY 1997
SPRINGFIELD

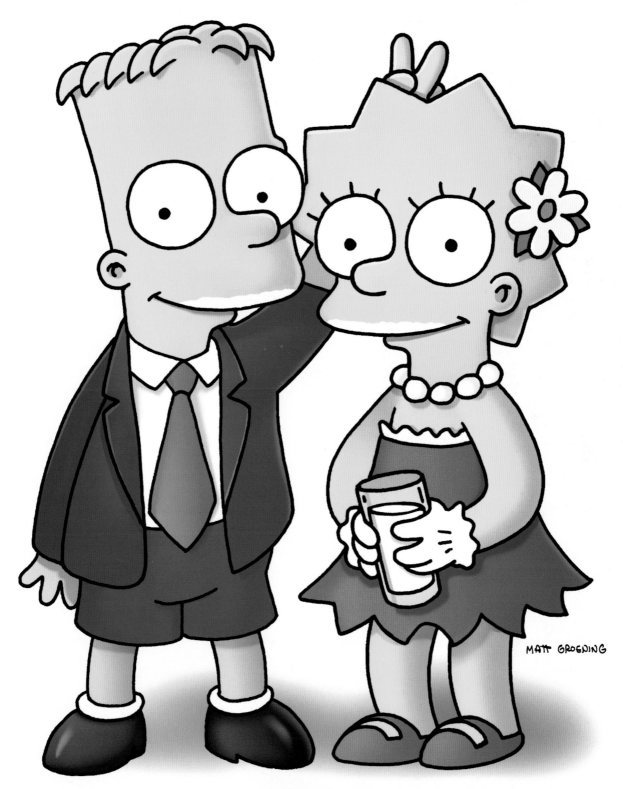

MILK

Where's *your* mustache?℠

Super Bowl **XXXI**

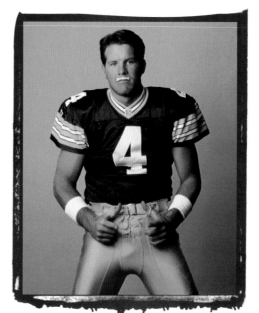

This photo of Brett Favre and Drew Bledsoe made history: it was the first time opposing Super Bowl quarterbacks appeared in an ad together. Looks pretty simple, but the planning had to start months before, as we contacted and got approval from every potential Super Bowl quarterback. Then we ran into scheduling conflicts that forced us to shoot the two heroes separately, only to digitally splice them together later.

World-famous sports photographer Walter Iooss, when shooting Brett's photo, said, "Hey, you just won the Super Bowl. Give me a pose that says you've just had the biggest score of your life!"

Brett struck his favorite pose. Two-thumbs up!

JANUARY 13, 1997
BOSTON, MASSACHUSETTS

JANUARY 14, 1997
GREEN BAY, WISCONSIN

Brett FAVRE

The morning after Green Bay's win, Brett appeared again. It was an exciting finish, for us. The game ended close to midnight, eastern time. We had two ads at the newspaper ready to run, one with Brett, the other with Drew. *USA Today* had instructions to run the winner—we had our fingers crossed they ran the right one. It was no problem. This is the first time Drew's ad has been seen.

JANUARY 14, 1997
GREEN BAY, WISCONSIN

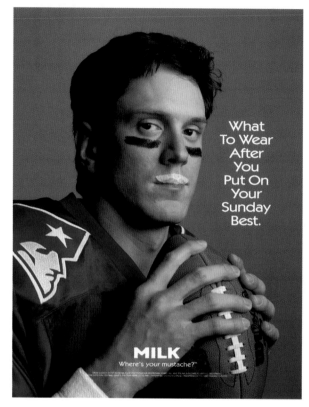

What
To Wear
After
You
Put On
Your
Sunday
Best.

MILK
Where's your mustache?

Some call our
Super Bowl win
destiny. I call
it 29 years overdue.
But building
a great team takes
time. So does
building a strong
body. With 9
essential nutrients,
milk can help.
Just stay with it.
Every day.
Because as my
teammates will tell
you, being the best
doesn't happen
overnight.

MILK

Where's *your* mustache?℠

Michael JOHNSON

Michael Johnson is so fast he arrived at the studio for his milk mustache portrait the day before it was scheduled to take place.

Okay, that's a joke. Michael Johnson's speed is not. His 1996 Olympic world record run certified him as the fastest man in the world.

FEBRUARY 5, 1997
NEW YORK CITY

Michael JOHNSON

Michael Johnson is so fast he arrived at the studio for his milk mustache portrait the day before it was scheduled to take place.

Okay, that's a joke. Michael Johnson's speed is not. His 1996 Olympic world record run certified him as the fastest man in the world.

FEBRUARY 5, 1997
NEW YORK CITY

Some call our
Super Bowl win
destiny. I call
it 29 years overdue.
But building
a great team takes
time. So does
building a strong
body. With 9
essential nutrients,
milk can help.
Just stay with it.
Every day.
Because as my
teammates will tell
you, being the best
doesn't happen
overnight.

MILK

Where's *your* mustache?℠

Conan **O'BRIEN I**

One for St. Patrick's Day. O'Milk, of course.

We opted to dress Conan in a lime green shirt after he shot down our idea of dressing as a leprechaun. "I do have some standards," he said with mock aloofness.

The copy tantalized people to check out our milk Web site (www.whymilk.com) to find out what was in the green concoction Conan was drinking. They found a recipe for a delicious green milk drink just right for St. Patrick's Day.

A day or two after the ad ran, Conan did a sketch on his television show where he contacted his ancestors via a Ouija board. At one point, he was told that he was an embarrassment to the O'Brien name. "Why?" Conan asked. The Ouija board revealed a photo of Conan with his green milk mustache.

FEBRUARY 5, 1997
NEW YORK CITY

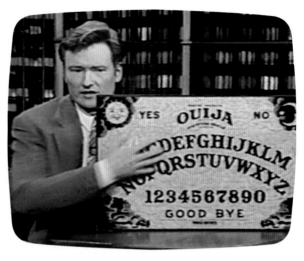

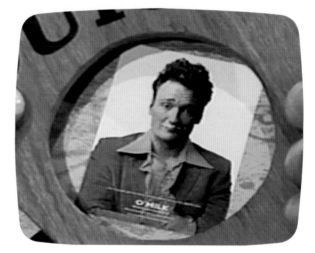

In the time it takes to read this, I set a world record in the 200 meter. Was it my unique posture and upper body strength? Or did the fat free milk in my healthy diet help? After all, that's what many pro trainers recommend. One thing's for sure. It wasn't just the gold shoes.

MILK
Where's *your* mustache?℠

I don't usually get this many nutrients when I drink on St. Patrick's Day.

O'MILK

Where's *your* mustache?℠

What's Conan drinking? Find out at www.whymilk.com

CONAN O'BRIEN ©1997 NATIONAL FLUID MILK PROCESSOR PROMOTION BOARD

Conan O'BRIEN II

This is one of our most popular ads. People ask for it all the time. Some, in fact, offer money. "Sell me the ad" is a refrain we constantly hear. "I'll pay you whatever you want!" "Take my credit card." "Here's twenty dollars."

People are always requesting reprints of all our ads.

The most bizarre event concerned Marlboro, New Jersey. First one kid called. Then another. And another. Then another, another and another. Altogether over one hundred people from Marlboro called, not just kids, but mothers, fathers and grandmothers.

Conan was the only one to have two ads appear simultaneously.

FEBRUARY 5, 1997
NEW YORK CITY

I ate lunch alone.
Girls avoided me. I was
teased by bullies. And that
was just this afternoon.
What else hasn't changed
since grade school?
I still drink milk.
Big guys need the calcium
as much as kids do.
Plus bones grow until age 35.
About the same time I'm
likely to start dating.

MILK

Where's *your* mustache?℠

Jonathan Taylor THOMAS

The original idea for the Jonathan Taylor Thomas photo was to have him sitting in front of a makeup mirror.

After kicking the idea around a bit, we decided that what we really wanted was to downplay Jonathan's role on television's *Home Improvement* and promote J.T.T. as a teenage heartthrob.

We came up with the garage concept. There wasn't one woman on the set that day that didn't think he looked cute.

Guess it worked.

APRIL 18, 1997
CULVER CITY, CALIFORNIA

94

Sure I'm young.
But I know a lot about girls.
Stuff they don't even know.
Like, 8 out of 10 don't get
enough calcium. Big mistake,
but easy to fix. Just get
at least 3 glasses of milk a day.
It has lots of calcium
to help bones grow strong.
Of course, milk helps me
too. I look older with
a mustache.

MILK
Where's *your* mustache?℠

Larry **KING**

Larry King created not just another TV talk show, but one that helps set America's agenda.

Everyone from presidential candidates to presidents to celebrities from every walk of life, including those who enjoy a moment in the sun because they are in today's headlines, appears on Larry's show. The world sees, the world listens, the world participates.

Because he and his show are so intertwined, we decided to photograph Larry right on the set of *Larry King Live*.

So the set was brought to our stage. Just like magic, it appeared and so did Larry: shirtsleeves, suspenders, forcefully leaning into the camera, saying "This is Larry King Live."

With a milk mustache, of course.

APRIL 18, 1997
LOS ANGELES

After 40 years in broadcasting, I've got my finger on the nation's pulse. So take it from me. Drink fat free milk. Studies suggest that a healthy diet rich in lowfat dairy products may help lower the risk of high blood pressure. Listen to the King and drink up, America.

MILK

Where's *your* mustache?℠

LeAnn RIMES

LeAnn Rimes was photographed in true country fashion on an old dirt road next to a rusty pickup truck. Hey, sounds like a song!

LeAnn's shoot went off without a hitch, although the unusually cold wind for early spring got us a little nervous.

LeAnn was scheduled to perform on an award show later that week and we were afraid she might catch a cold. That's when Norman Stewart, our milk mustache food stylist, handed her his favorite blanket.

The blanket perfectly matched his Jaguar's interior. Trouble was, LeAnn took the blanket with her when she left.

Oh well, maybe it's time for a new Jag.

APRIL 19, 1997
LEBEC, CALIFORNIA

As a 15-year-old country singer, I've sung songs about broken hearts. But never broken bones. Because I keep mine strong. And getting enough calcium helps. So I drink lots of 1% milk. Which means I may not have to worry about osteoporosis when I'm old. Like, say, 19.

MILK
Where's *your* mustache?℠

Paul SHAFFER

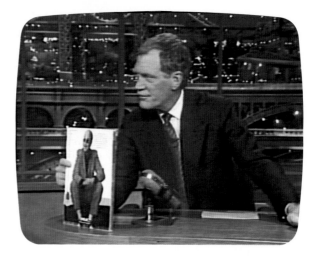

Celebrities fall into two camps when it comes to the copy. Some choose to leave the writing to us, while others wouldn't have it any other way than to personally help write it.

Paul Shaffer spent hours on the phone with copywriter Dan Kendall helping craft his chocolate milk song. "Don't say 'cat' say 'man,' it's much hipper! Singing 'Chocolate milk' twice on the intro is much cooler than three times. Don't call me Paul, my friends call me Shaffe."

Shaffe told us that his favorite ad was Van Halen, which had run in *Rolling Stone*.

After Paul's ad appeared on the back cover of *Rolling Stone*, David Letterman held it up on his TV show, but did Paul one better by showing that he was on the *front* cover. The actual cover shot was of Courtney Love, Madonna and Tina Turner; Dave had had his picture inserted in place of Madonna's.

Fun bit…and fun ad.

MAY 6, 1997
NEW YORK CITY

What's a hip drink?
Let me lay some lyrics on you,
man. Hey, *Chocolate* milk.
It's nutty, it's too neat. Get your
nutrients with a koo-koo beat.
Get it lowfat, get it fat free.
It's a swingin' chocolata treat.
Chocolate milk, oh yeah!

MILK
Where's *your* mustache?℠

Ekaterina GORDEEVA
AND *Daria* GRINKOVA

Daria stole the show.

Animated. Beautiful. Spontaneous. Daria's smile lit up her face and every face in the crew. A natural crowd pleaser. Even a bit of a ham mugging for the camera. She was the child of a thousand faces. Each one beautiful. Each one joyful. Each one stealing your heart.

Ekaterina, "Katia," her mother, played along with her little Shirley Temple, graciously giving her the spotlight.

MAY 6, 1997
NEW YORK CITY

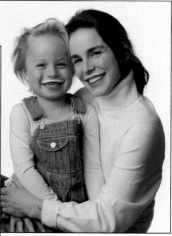

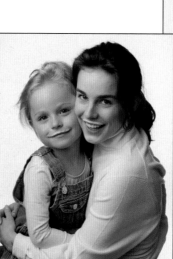

My daughter has my eyes. And my smile.
Well... almost. She also shares my love of milk.
On ice, of course. Which could come in handy,
considering the calcium helps give us something
every skater needs. Strong ankles.

MILK
Where's *your* mustache?℠

Arie LUYENDYK
INDY 500

Since day one, the idea of doing a milk mustache of the Indy 500 winner was a natural. For over half a century, the winner has celebrated his victory by downing a bottle of milk at the finish line.

Just our luck this time, the Indy 500 was delayed three times due to rain. It rained so much in Indianapolis that we wondered if this would be the first year that they didn't have an Indy 500.

Luckily for Arie—and us—they did.

MAY 25–27, 1997
INDIANAPOLIS

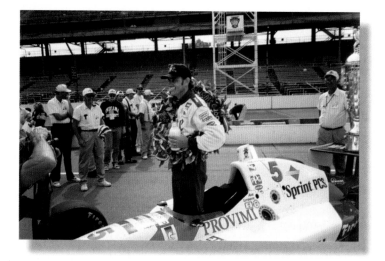

Winning the Indianapolis 500 is one thing every
race car driver wants. Strong bones are another. Which
may be why milk is always served in Victory Lane.
It has protein to help build muscle and calcium to help
strengthen bones. All a race car driver needs.
Except maybe a cup holder.

MILK

Where's *your* mustache?℠

HANSON

We first got wind of Zac, Taylor and Isaac Hanson from an article we spotted in *The New York Times*. It predicted the brothers would have a solid first album and a promising career ahead of them. Believing in them, we signed them up.

Their first single, "MMMbop," not only soared up to the top of the charts, it became number one in America. When our ad debuted in teen magazines nationally, Hanson seemed to be on every magazine cover and in every news story, everywhere.

The only ones who weren't surprised by the group's stunning success were those of us who have teenage daughters at home. Their bedroom walls, plastered with multiple pictures of Zac, Taylor and Isaac cut from their favorite magazines, now had a milk mustache portrait ad firmly stapled, taped or thumbtacked next to them.

JUNE 18, 1997
NEW YORK CITY

Here's your chance to find out just how much you know about Hanson:

1. What music did Isaac ask to listen to at their photo shoot?
 A. "MMMbop"
 B. Elvis Presley
 C. Michael Jackson
2. Is Taylor . . .
 A. right-handed
 B. left-handed
3. What food did Zac refuse to try at lunch?
 A. Thai chicken
 B. Salmon
 C. Crab cakes

ANSWERS: 1. B, 2. A, 3. C

What do we drink
when we write songs?
MMMmilk. And you
should too. 'Cause 8 out of
10 of you don't get enough
calcium. But at least
3 ice-cold glasses a day
will give your bones lots
of calcium to grow strong.
In fact, we aren't sure
what's getting bigger
faster. Our new single,
or our brother Zac.

MILK
Where's *your* mustache?℠

David **COPPERFIELD**

For David Copperfield's milk mustache ad, we wanted to create something special.

Working closely with David, we devised an illusion involving a floating glass of milk. David actually floated the glass between his hands for the photo shoot, and no, we can't tell you how he did it. But we did make one change to the image. After reviewing the photo, we wondered if the floating glass idea was big enough for David Copperfield. Remember, this is the guy who made the Statue of Liberty disappear. So David flipped the glass upside down.

Even we don't know how he did that!

**JUNE 26, 1997
LAS VEGAS**

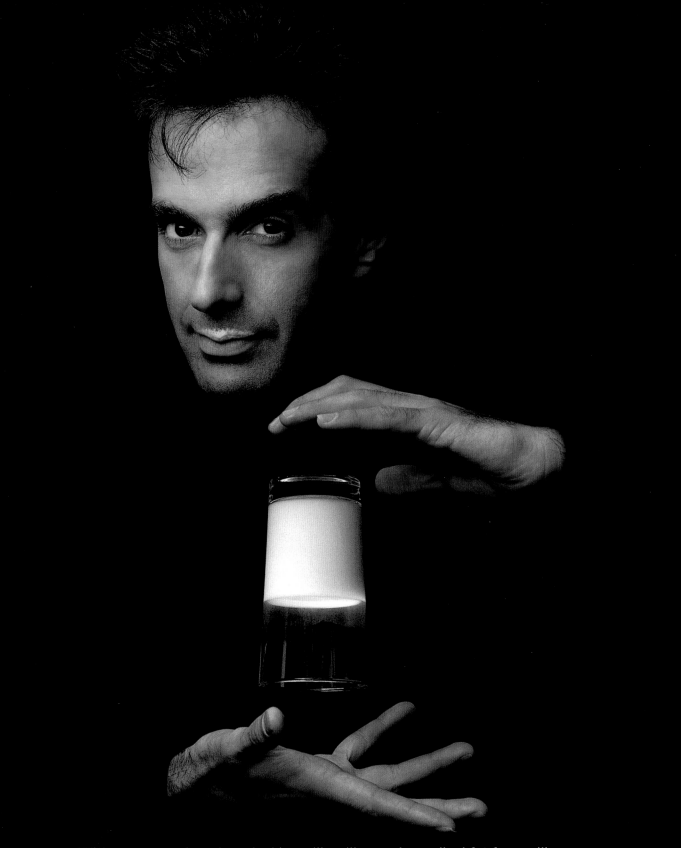

With a wave of my hand, skim milk will now be called fat free milk. But this is no illusion. Skim milk has always been fat free. And it's always had all of the nutrients of whole milk, too. Which reminds me, it's time to perform my favorite bit of magic. Making it disappear.

MILK
Where's *your* mustache?℠

Elvis IMPERSONATORS

To expand the milk campaign beyond actors, athletes and super-models, we tapped into Elvismania, mama.

The ad ran in newspapers and weekly magazines to commemorate Elvis's birthday.

One of the first hurdles we had to clear was getting approval from Elvis Presley Enterprises. They requested that no overweight Elvis impersonators be used.

Fortunately they had no problem with tacky jumpsuits and fake side-burns.

JUNE 26, 1997
LAS VEGAS

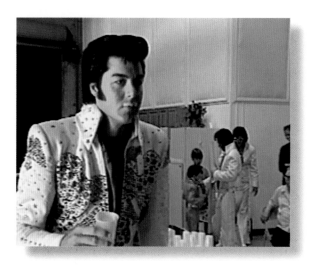

There's a ton of impersonators out there, baby. And we'll
thank you very much to get the original. Milk. It comes with calcium
naturally. So we drink 3 glasses a day. Ice cold. 'Cause after all,
mama, where would our act be without a strong pelvis?

MILK
Where's *your* mustache?℠

Amy **GRANT**

Amy Grant had a major hit, "Baby Baby."

She also has a loyal following of many fans who watch her every move.

So it came as a big surprise when they saw her wearing her milk mustache.

Amy followed her milk mustache appearance with another mega-hit song, "Takes a Little Time."

SEPTEMBER 8, 1997
LEBEC, CALIFORNIA

I may be a pop singer, but soda never helped me climb the charts.
For me, it's fat free milk. It's delicious, rich in calcium and has all the nutrients of
whole milk without the fat. And baby, baby, does it hit the spot.

MILK

Where's *your* mustache?℠

Dennis **FRANZ** AND
Jimmy **SMITS**

Dennis Franz and Jimmy Smits were photographed at Fox studios on the set of *NYPD Blue*. They posed for their photo after a long day of filming. Everyone was tired and edgy but was all smiles as soon as the milk started flowing.

Or should we say, frowns. We wanted Jimmy and Dennis to look natural. Naturally mean, that is.

There's something brazenly unexpected about two no-nonsense cops, ready to rough up a punk or two, taking a break with a glass of milk.

"I'm sorry, officer! I *will* drink my required three glasses of milk a day! I promise!"

SEPTEMBER 9, 1997
CENTURY CITY, CALIFORNIA

Turns out roughing up punks ain't really necessary. On account
of most guys and gals hurt *themselves* by not getting enough calcium.
So reach out for 3 glasses of milk a day. Your body will thank you.
Especially if we don't have to tell you again.

MILK

Where's *your* mustache?℠

TV MOMS

Shirley Jones, Marion Ross and Florence Henderson are three of the world's most familiar faces. Shirley Partridge, Mrs. Cunningham and Carol Brady are three of the world's most familiar names.

When we first came up with the idea of having three of America's most famous TV moms, we weren't sure how each would react. To our surprise, they not only gave us a kiss on our foreheads, they couldn't wait to get back into costume.

It had been decades since they appeared in their career-defining roles. They didn't exactly walk in off the street ready to bake cookies and make the beds but as soon as they slipped back into their famous characters, everyone was magically transported back to the seventies.

SEPTEMBER 18, 1997
NEW YORK CITY

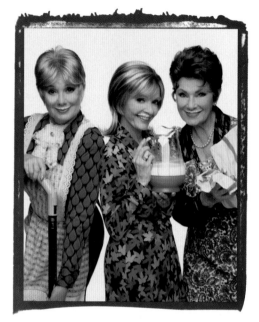

Don't play ball in the house. Joanie, go to your room.
Here's another all-time great mom line: Drink your milk.
Unlike hairdos, milk's 9 essential nutrients will always
be in style. Which is why your kids should drink it. Groovy.
Another problem solved in less than 30 minutes.

MILK

Where's *your* mustache?℠

1997 **WORLD SERIES**

Who would have thought that both of the ace pitchers from the Cleveland Indians and the Florida Marlins would lose two games each in the World Series? Certainly not us.

We were stunned when we pulled up to the airport to head home after the shoot in Miami. Here it was: the first game of the World Series...the first time the Florida Marlins had played in the big game...the first time *any* team from Florida had been to the Big One.

What dominated the front page of the *Miami Herald*? A news photograph of Orel Hershiser and Kevin Brown with their milk mustaches.

OCTOBER 17, 1997
MIAMI

Just A Reminder To Fill Your Pitchers With Milk.

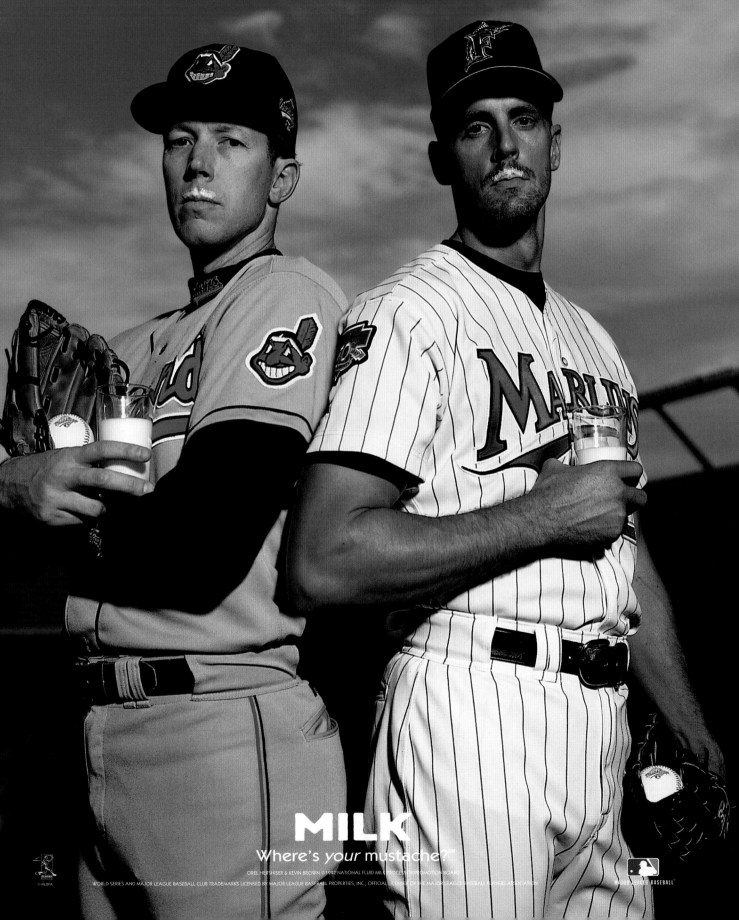

MILK

Where's *your* mustache?

Kevin **BROWN**

Here's Kevin's ad, along with the photo of pitcher Orel Hershiser, that would have run instead had the Indians won.

Cy Young winner Orel Hershiser is one of baseball's greatest pitchers.

His sinking fastball and slider are notorious for striking out batters faster than you can say, "Strike three!" That he might be doing something to the ball was not confirmed or ruled out at the shoot.

But we can confidentially pass on that when Orel asked an assistant to hand him his glove, he playfully cautioned, "Be careful you don't cut your fingers on the sandpaper."

OCTOBER 17, 1997
MIAMI

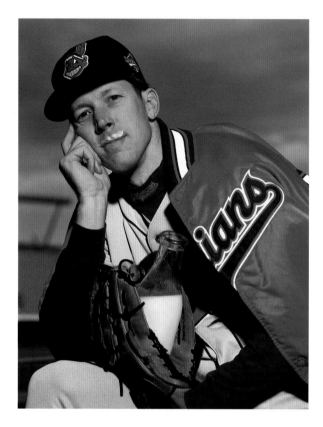

Great
Things Happen
When You
Pour It On.

MILK
Where's *your* mustache?℠

Elle MACPHERSON

There's something about pregnant supermodels that is unlike anything you've ever seen before. The only thing about them that looks pregnant is their belly.

Cover up Elle's belly and see for yourself.

When Elle stepped onto the set for her milk mustache portrait she gazed into a full-length mirror, hands on her hips. She then moved her hands down her sides then back up to her hips. "I'm just trying to get used to my new look," the beautiful lady explained.

NOVEMBER 20, 1997
NEW YORK CITY

My baby is going to have a great body. Not just because of my genes, but because of my drink. Milk. I'm drinking more than usual. So my baby's bones will get the calcium they need, and mine will too. Plus, milk tastes great. Especially with pickles.

MILK

Where's *your* mustache?℠

ELLE MACPHERSON ©1998 NATIONAL FLUID MILK PROCESSOR PROMOTION BOARD

Sarah Michelle GELLAR

Asked to create the first milk mustache ad targeted at teenage boys, we knew just whom to get. Buffy the Vampire Slayer.

Sarah Michelle Gellar stars as the show's heroine. She has the same problems that trouble teens everywhere: studying for midterms, getting a pimple before a big date and slaying vampires. When prowling graveyards and karate-kicking bloodsuckers, Sarah wears sexy little outfits.

What more could a teenage boy want?

NOVEMBER 20, 1997
NEW YORK CITY

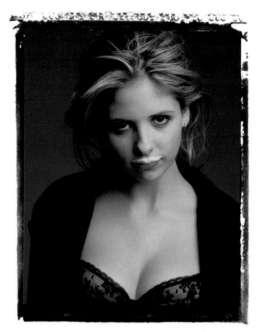

Revealing outfits and the undead. What else can't most young guys get enough of? Calcium. But there is a mouth-watering solution. Milk. It can help provide the calcium growing bones need to stay strong. A real must. Especially if you plan on sticking your neck out.

MILK

Where's *your* mustache?℠

Super Bowl **XXXII**

Nothing personal against Green Bay, but we were all privately hoping that John Elway would be triumphant on Super Bowl Sunday.

John is one of the best quarterbacks who ever played the game. He had put in the years, the sweat and the drive but had come home emptyhanded three times from the Super Bowl.

Super Bowl XXXII would be John's moment as the champion of champions.

Couldn't have happened to a nicer guy.

JANUARY 13, 1998
DENVER

JANUARY 14, 1998
GREEN BAY

How Bad They Want It Is Written
All Over Their Faces.

MILK

Where's *your* mustache?℠

John ELWAY

Reggie White was the NFL's top
sacker in 1997. Many believed he
was the only thing standing between
John Elway and a long-overdue
Super Bowl championship.

When we asked Reggie if he had
a message for Elway, he scowled:
"I'm gonna wipe that milk mustache
right off his face." Turns out, John
Elway laughed all the way to the
end zone.

JANUARY 13, 1998
DENVER

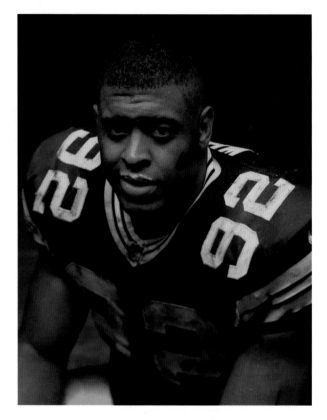

I was discouraged
after my first two attempts.
And depressed after
my third. But on my fourth
try, I finally did it.
I found a drink that provides
the 9 essential nutrients
active bodies need. Milk.
Why did it take me so long?
Let's just say I hate
to be rushed.

MILK

Where's *your* mustache?℠

Tyra BANKS II

Tyra Banks has appeared twice. The first time in a T-shirt and jeans.

The second time in a string bikini that only appeared once in *Sports Illustrated*'s celebrated swimsuit issue.

The rest, as they say, is history.

Copywriter Bruce Frisch worked hard to get the copy just right. After all, nobody just looks at the pictures in *Sports Illustrated*'s swimsuit issue, do they?

MAY 9, 1996
NEW YORK CITY

Stop drooling and listen. One in five victims of osteoporosis is male.
Don't worry. Calcium can help prevent it. And ice cold, lowfat milk is a great source
of calcium. So don't sit there gawking at me. Go drink some milk.

MILK

Where's *your* mustache?℠

James **CAMERON**

Titanic had been nominated for fourteen Academy Awards.

James Cameron wrote, produced and directed it. It was his labor of love and it showed in every frame. Although most Americans would not have known Cameron by face if he had shown up on their doorstep, we gambled most people would know his face the morning after the Academy Awards. We were right.

Cameron won big-time, and so did we. His face dominated newspapers across the country. As did our Cameron milk mustache moment which appeared in *USA Today* the same day.

MAY 1997
ON LOCATION FOR *TITANIC*

I Like To Float Big Chunks Of Ice In Mine.

MILK

Where's *your* mustache?℠

Marilyn MONROE

We always look for ways to keep the campaign fresh, unexpected and surprising.

This "news story" appeared in *USA Today* on April 1, 1998.

You'll never guess who took the bait. Jennifer Mantz, the original writer on the campaign, who now works in our London office, was sitting at her desk reading the paper when she came across this article about the Andy Warhol "Marilyn Monroe" discovery. She immediately sent a fax about it to us. Only when she typed in the date did she realize she had been April-fooled.

APRIL FOOL'S DAY, 1998

Unknown version of famous Warhol painting found in Pittsburgh basement.

Formerly unknown painting by pop artist Andy Warhol depicting Marilyn Monroe wearing a Milk Mustache.

"I read the ad offering free art appraisals and took a chance. I had no idea it could be a real Warhol. I'm overwhelmed."

—Ms. Amy Heinemann

Conclusions about the painting's authenticity will be settled by chemical tests.

By Linda Edwards

An offer of a free appraisal for works of art has unearthed what appears to be a contemporary masterpiece that could be valued in the millions.

Marilyn With Milk Mustache

The painting in question, *Marilyn With Milk Mustache*, could be a formerly unknown portrait of Marilyn Monroe by pop artist Andy Warhol, whose paintings of the film star have been universally acknowledged as quintessential pop icons. Unlike the other silk-screen paintings in the series, this particular painting depicts Ms. Monroe wearing what appears to be a milk mustache.

Tobias Meyer, Worldwide Director of Contemporary Art at Sotheby's, the international auction house, is intrigued by the mustachioed Marilyn. When asked about its possible value, Mr. Meyer commented, "We are offering Warhol's *Orange Marilyn* this May in our sale of Contemporary Art. It has an estimated value of $4 million to $6 million.

"Warhol's images of Marilyn Monroe have always been extremely popular. If indeed the mustachioed Marilyn is authentic, I would imagine contemporary collectors would compete vigorously for it."

Conclusions will not be drawn regarding the painting's authenticity until chemical tests on the pigments and fibers of the mustache are closely compared with those in Warhol's celebrated Marilyn series.

Warhol Was a Milk Fan

Furthermore, consultations with Mr. Warhol's friends have confirmed that he was a big milk drinker. "Andy was known for his quirky sense of humor. This is just another example of art imitating life," said a friend of the late artist who frequented the Factory, the Warhol studio in New York City.

The owner of the painting is Ms. Amy Heinemann, who came into possession of the work when she inherited the contents of a studio apartment in New York City owned by her late uncle. The property was moved to Pittsburgh and stored in the basement of Ms. Heinemann's home.

"I didn't unpack anything until a few weeks ago," she said. "At that time, I read an ad in the newspaper offering free art appraisals and took a chance. I had no idea it could be a real Warhol. I'm overwhelmed."

The painting's value is increased by its rarity as well as by an odd confluence of timing. A popular advertising campaign for milk features celebrities wearing milk mustaches. When notified of the work, The National Fluid Milk Processor Promotion Board, which runs the milk mustache campaign, said it might consider acquiring the painting for future promotional use. Art collectors, dealers and others interested in the latest findings can call 1-800-949-6455.

Vanessa WILLIAMS

Vanessa is stunning.

Certainly one of the most beautiful and talented people in the world.

Although she has moved on to become an acclaimed actress on stage and screen, she still reigns as one of America's top vocalists, capturing eleven Grammy nominations.

So we photographed her in a recording studio. Naturally.

You'll notice that this ad is signed with "Got milk." Even though "Got Milk" is a different campaign for a different client, the public always lumped our campaigns together. Jay Leno, for example, would say: "Have you seen those 'Got Milk' ads?"— then show *his* hysterical versions of our milk mustache ads.

So why not put the two together in one ad? That's what we did.

APRIL 17, 1998
NEW YORK CITY

Beauty is not only skin deep. That's why I drink ice cold milk with my meals.
It has calcium to help prevent osteoporosis. And when I'm not doing movies,
albums or theater, I make time for my biggest fans: X-ray technicians.

got milk?®

Joshua JACKSON

A few short months ago, Joshua Jackson wrapped up his first season of *Dawson's Creek*. Hard to believe, but Josh was taken by surprise when we asked him to join our celebrated list of milk mustache luminaries. Guess he didn't know that when we asked teenage girls whom they'd most like to see as the next milk mustache celebrity, he won hands down.

JUNE 24, 1998
SANDY HOOK, NEW JERSEY

I can't help it. Women of all ages look up to me. Why? I'm 6 foot 2. Thanks in part to milk. The calcium helps bones grow strong. Considering 15% of your adult height is added when you're a teenager, that's good to know. Especially if you want to impress, let's say, an older woman.

got milk?

Tony HAWK

In a lifetime spent perfecting and defining the sport of skateboarding, Tony Hawk has won more awards on the half-pipe than almost everyone else combined.

Tony is not only *the* master at performing daredevil acrobatics, he invented and named many of the moves himself. Although young, Tony is already being called the "Father of Skateboarding."

The Los Angeles Times said Tony Hawk is "Michael Jordan on a 32-by-9-inch hunk of hardwood. Air Tony."

JUNE 30, 1998
CHELSEA PIERS SKATE PARK,
NEW YORK CITY

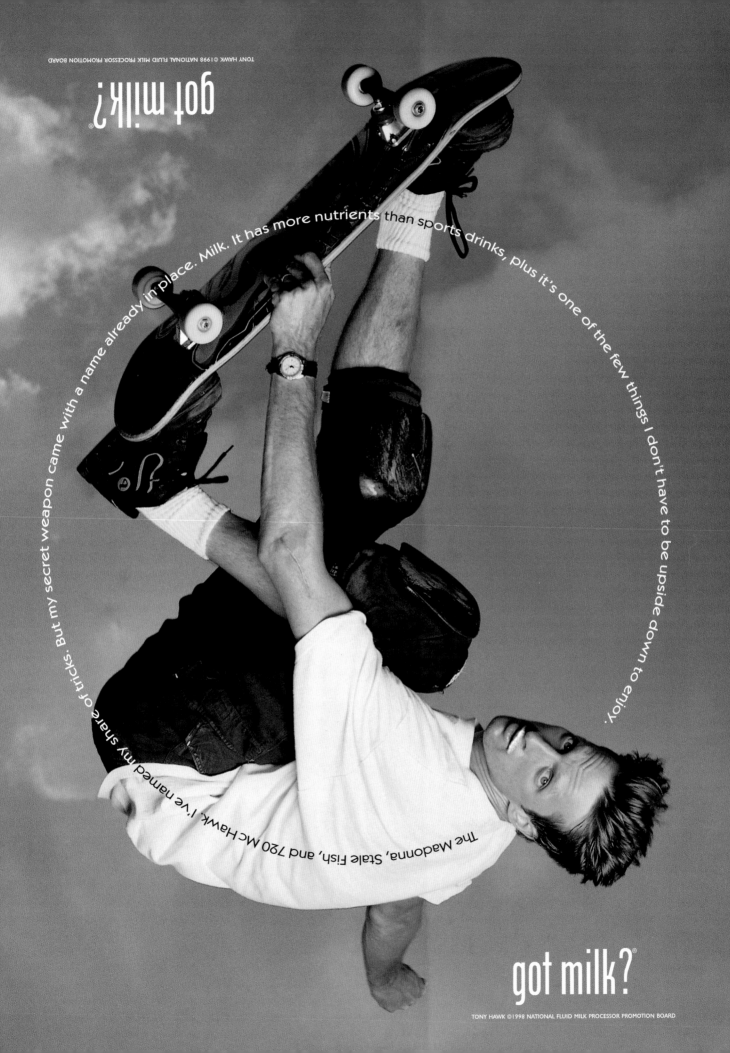

Seventeen Magazine
CONTEST WINNERS

Seventeen magazine asks its readers to tell us why they are "Mad About Milk" in a nationwide contest. They create their own ads.

The prize? The winner is published in the magazine, and she joins our gallery of celebrities.

India Daniels won the first year with her imaginative dress of milk cartons.

In 1998, sixteen-year-old Liz Elkins won. Sometimes genius is capturing the obvious. Tens of thousands of kids collect and trade our ads. Their bedroom walls are plastered with them. What did Liz do? She had herself photographed in her bedroom covered from floor to ceiling with milk mustache ads. Her copy is great.

MAY 9, 1996
NEW YORK CITY

http://www.whymilk.com

Some of us drink skim milk for the calcium and other nutrients. But most of us drink it 'cause it's fat-free. Me? I drink it because it's downright tasty. Whatever the reason, one thing's certain. If you want a body "to die for," skim milk can help. Besides, the little cartons really come in handy on those "Nothing-to-Wear" days.

MILK
"Where's your mustache?"

Out of all my hobbies, my favorites are acting and collecting milk ads.
How else could I keep up with my future fellow celebrities and learn cool milk facts?
Like, it has nine essential nutrients, including calcium and vitamin D, that help build
strong bones so I don't really "break a leg" when I perform.

MILK
Where's *your* mustache?℠

Our Own
MILKY WAY COMET

First Halley's comet. Then Hale-Bopp. And now a mysterious new comet.

Funny, it looks just like a milk mustache.

It was discovered when *Life* magazine published a commemorative issue of its 1969 special report on the *Apollo 11* mission. It was devoted entirely to the space program and to America's pioneers to the moon, Buzz Aldrin, Neil Armstrong, and Mike Collins.

We created a very special ad for the occasion. Because our milk mustache had become ubiquitous and so well known, we decided this would be the first time we would break with tradition and not show it on a celebrity's face. Rather, we would do the unexpected, and maybe make history in space.

Art director Steve Feldman came up with the ingenious idea of the milk mustache as a comet.

MARCH 15, 1996
LOS ANGELES

144

MILK

Where's *your* mustache?℠

Spoofs, Parodies, Rip-offs:
Everybody Gets into the Act

From the moment it burst on the scene, the milk mustache became part of pop culture.

It has been spoofed, parodied, copied, and ripped off from one end of the globe to the other.

Although nary a word was spoken, the milk mustache spoke an international language.

It showed up everywhere from Leno to Letterman, sit-coms to movies, greeting cards to politicians running for office in the Philippines.

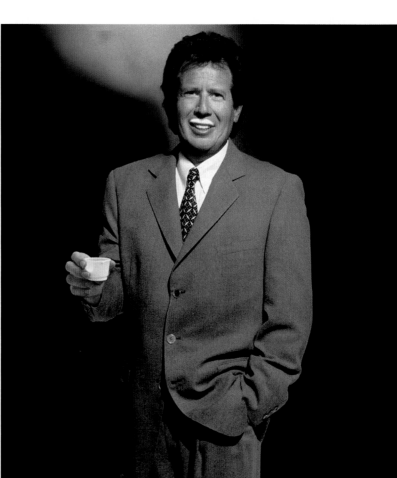

GOT MILK OF MAGNESIA?

The LARRY SANDERS Show
starring Garry Shandling
ALL NEW SEASON BEGINS
SUNDAY, MARCH 15, 10 PM **HBO**
hbo.com ©1998 Home Box Office, a Division of Time Warner Entertainment Company, L.P. All rights reserved. ® Service marks of Time Warner Entertainment Company, L.P. IT'S NOT TV. IT'S HBO

The Larry Sanders Show starts its season with you-know-what.

MOTOR OIL
It's not just for cars anymore

Jay Leno sports a motor-oil mustache in his own commercial parody on *The Tonight Show.*

Got Tuesday?
Are you getting enough? Tonight, get double the recommended allowance of Tim on two great episodes of Home Improvement. In between, get a taste of Soul Man, the wholesome new Tuesday night comedy. Top off the night with a healthy dose of Spin City, and you'll get all the laughter you need.

8:00 abc 7 8

ABC's Tuesday-night lineup captures the milk mustache.

146

Peri Gilpin on *Frazier*.

My policy is to down a tall glass of cold cow juice every morning with breakfast -- whether it's scrambled eggs and grits, biscuits and gravy, a 12-pack of chocolate donuts, or all of the above. So do I love milk? All I can say is, "I inhale it."

As First Lady, I'm always busy, busy, busy -- whether I'm visiting my lawyers, trying to locate old, lost records, or testifying before grand juries. So I like to grab a quick glass of fresh milk. And to the best of my knowledge, all I can say is "I love milk" and that's the whole truth. And if there is any other information I can shed on this issue, I promise to cooperate to the best of my ability.

The milk mustache has appeared on everything from greeting cards to political cartoons.

OK. I'll admit it. I'm not a kid anymore. That's why when I fix breakfast every evening I like a little extra something to help me make it through the night. Besides tasting great, a pint a day will provide all the goodness a healthy body once needed, and trust me, when you get to my age, that's just what the doctor ordered.

GOT BLOOD?

VAMPIRE COUNT DRACULA BLOOD ADVISORY BOARD

Dracula never looked so good, Mel Brooks's funny movie.

147

The German edition of *Men's Health*.

An ad for Tomb Raider II.

A company in Israel liked our ads so much, they made their own.

got an emmy?

MURDER, SHE WROTE

CBS ran this ad when Angela Lansbury
was nominated for an Emmy.

MILK

Father Guido Sarducci suggests a new milk
mustache celebrity on *Late Night* with
Conan O'Brien.

From *The Single Guy*.

"'AUSTIN POWERS' IS A VERY, VERY FUNNY MOVIE!"
— Joel Siegel, GOOD MORNING AMERICA

got austin?

debonair. defiant. defrosted.

Austin Powers raises a glass.

Spoofs from *The Tonight Show* starring Jay Leno...

and *The Late Show* with David Letterman.

From *Caroline in the City*.

An ad for Comedy Central.

THE FOLKS WHO MADE IT ALL POSSIBLE—
THE MILK PROCESSORS BOARD OF DIRECTORS
AND STAFF:

Robert W. Allen

Robert E. Baker

Rick Beaman

Miriam Erickson Brown

Scott Charlton

Tom Dolan

Mark V. Ezell

Robert L. Fleming

H. Denny Gaultney

Gary E. Hanman

David Coates

Chuck Hills

John Hitchell

Jon Jilbert

Jeffrey L. Koehler

Phillip A. Littell

Michael Marcus

Martin J. Margherio

C. Scott Mayfield

Ronald W. Mong

Arthur J. Pappathanasi

Richard L. Robinson

Ron Rubin

Gary J. San Filippo

Dave Schwain

Leonard J. Southwell

Richard Sturgeon

Joe W. Van Treeck

Wayne Watkinson

James T. Wilcox Jr.

PHOTO AND ILLUSTRATION CREDITS

Clinton/Dole
PHOTOGRAPHY: EDDIE ADAMS

Super Bowl Ads: Brett Favre,
Drew Bledsoe, Reggie White,
John Elway
PHOTOGRAPHY: WALTER IOOSS

Indy 500, Arie Luyendyk
PHOTOGRAPHY: WALTER IOOSS

World Series Ad: Kevin Brown,
Orel Hershiser
PHOTOGRAPHY: RICHARD CORMAN

The Simpsons
THE SIMPSONS™ AND © 1998
TWENTIETH CENTURY FOX FILM
CORPORATION. ALL RIGHTS
RESERVED

James Cameron/Titanic
PHOTOGRAPHY: DOUGLAS
KIRKLAND

Halley's Comet
JAMES BALOG/TONY STONE
IMAGES

Marilyn Monroe
© 1999 ANDY WARHOL
FOUNDATION FOR THE VISUAL
ARTS/ARS, NEW YORK

India Daniels and Liz Elkins
Seventeen Winner Ads
PHOTOGRAPHY: ANDREW ECCLES

All other ads photographed by
ANNIE LEIBOVITZ

Index

ABOUT THE AUTHORS

JAY SCHULBERG is the Vice Chairman, Chief Creative Officer of Bozell Worldwide, the advertising agency. He has created or has been responsible for campaigns for *The New York Times*, Merrill Lynch, MassMutual, Lycos, Unisys, Excedrin, Ray-Ban, Jeep, Chrysler, Minolta, American Express, Hershey's, Huggies, Hardee's, Maxwell House Coffee, International Paper, Paco Rabonne, and many, many other products. He oversees the work of ninety offices in fifty-three countries. Prior to joining Bozell, Jay was Creative Head of Ogilvy & Mather, New York.

And yes, he does have a milk mustache.

BERNIE HOGYA is a Creative Director at Bozell Worldwide, New York. He has art directed or supervised every ad in the milk mustache campaign. After rubbing shoulders with the likes of movie stars, sports legends, and supermodels, Bernie remains the same simple, humble, unaffected ad guy that started out in this business with a dream to do great work. The only exception being that he now wears a pair of shades indoors every now and then and calls co-workers "babe."

SAL TAIBI is a Senior Partner and Account Director at Bozell Worldwide. For the past four years, he has been overseeing the milk mustache campaign for the Milk Processor Education Program. Recently, he expanded his role within the dairy industry by adding responsibilities for Dairy Management, Inc., the association that represents milk producers. Prior to joining Bozell, Sal spent thirteen years in Account Management at Saatchi & Saatchi Advertising. His two wishes are for world peace and to see a milk mustache on every face in America (not necessarily in that order).